PROFESSIONAL FILTER
TECHNIQUES
FOR DIGITAL PHOTOGRAPHERS

STAN SHOLIK

AMHERST MEDIA, INC. ■ BUFFALO, NY

Published by:
Amherst Media, Inc.
P.O. Box 586
Buffalo, N.Y. 14226
Fax: 716-874-4508
www.AmherstMedia.com

Publisher: Craig Alesse
Senior Editor/Production Manager: Michelle Perkins
Assistant Editor: Barbara A. Lynch-Johnt

ISBN-13: 978-1-58428-196-2
Library of Congress Control Number: 2006925664

Printed in Korea.
10 9 8 7 6 5 4 3 2 1

TABLE OF CONTENTS

INTRODUCTION

While modern digital cameras provide a wide range of useful settings to automate the picture-taking process, they are programmed to deliver an objective rendition of a subject within the range of the camera's settings. Photographers, on the other hand, are often creating an image in response to their subjective reaction or their creative vision.

Preset portrait, landscape, close-up, and other modes only provide a quick group of settings, selected by the camera-manufacturer, that deliver usable but often lifeless photos. For instance, while the "cloudy" preset of your digital camera may record an overcast day with a full range of values from light to dark, you may have wanted to interpret it as dark and moody. Where your digital camera may record the portrait of a loved one in sharp detail, your subjective response may have been quite different.

Digital cameras have changed the way many photographers are taking pictures.

For photographers who have advanced beyond the point-and-shoot stage, there comes a time when their digital camera's interpretation of the scene does not match theirs. I have written this book for those photographers looking to expand their creative reach. By using filters, either while taking the pictures or later in the computer, you can take control of your photography and create images that express your vision, not your camera's.

Using filters is a simple, inexpensive way to move from simply capturing pictures to creating images. For example, photographers who have used infrared film to express their vision can now produce photos with digital images and filters and enjoy a degree of control that was unavailable in the darkroom. Filters also serve another important function, that of correcting an image. From flesh tones in portraits to color-balancing an architectural interior, photographers can use filters to quickly achieve results that would be time-consuming to accomplish in any other way.

THE IMPACT OF DIGITAL

Digital cameras have changed the way many photographers are taking pictures. But while many things have changed, many things remain the same. It is as important as ever for photographers to understand the characteristics of light itself. This knowledge allows us to use the right filter at the right time to correct or interpret the subject to our vision. It is also important to understand a little about how digital sensors work and how they differ from film. For photographers who want to brush up on their color theory and knowledge of digital sensors, the appendix at the end of this book is provided for reference.

An advantage of software filters is that they can be applied to any image in postproduction. I've always liked the left image, which I shot years ago on film, but was never really happy with the sky. Using Nik Software's Bi-Color Violet/Pink filter (Filter>Nik Color Efex Pro 2.0: traditional filters> Bi-Color Violet/Pink), I was able to enhance the sky and make it to my liking (below).

Plug-in Filters. While hardware filters, which are placed over the camera lens while taking the picture, are still very useful, today we also have the option to use plug-in filters in an image-processing program after the picture has been taken. Many such filters come installed with image-processing programs, and there are countless additional filters available for purchase.

But why purchase a set of software filters when you could create each effect for yourself with the tools in your image-processing program? For one thing, few of us have the time or skill to do this. But even if we could create the effect we like for an image, pre-built filters have a number of advantages. They are already there in our computer, waiting for us to experiment with them, for example. Plus, they give us a repeatable baseline with lots of controls for applying them to very different images. Additionally, most of the filters allow settings to be saved to a file so the same effect can be quickly and easily applied to other images.

A well-composed, correctly exposed image is always your best starting point.

An added advantage to using software filters is that, unlike hardware filters which must be used at the time the image is shot, you can apply software filters to *any* digital image. The image could already exist in your archive from your digital camera, or it could be a scan of a film image. But it is important to remember that no filter, software, or hardware is going to make a mediocre photo into a winner. While filters can correct and enhance, they can't do magic. A well-composed, correctly exposed image is always your best starting point.

HARDWARE VS. SOFTWARE FILTERS

If you prefer spending your time with your cameras taking pictures, you will likely prefer using hardware filters whenever possible to minimize the time spent in front of a computer monitor. But if you enjoy the computer work and the controls it offers, you will likely gravitate to the software filters. Another factor in choosing between the two approaches is determining which one will give you the result you're after.

This book will compare the results of using filters on the lens against filters in the computer in hopes that by seeing examples of both you will be able to make an informed decision about when to use each type of filter. There is really no right or wrong in most cases; the results are simply different. Knowing when to use each one allows you to achieve the result you desire.

LEVEL OF EXPERTISE

Throughout this book, I am assuming that the reader is an advanced photographer using a digital single lens reflex (SLR) camera. While there are adapters available to use filters on point-and-shoot digitals, and this book certainly applies to those cameras as well, the disadvantages far outweigh the advantages of using filters on non-SLR cameras.

I'm also assuming that the reader has a solid understanding of digital camera operation and exposure fundamentals, as well as a basic understanding of lighting principles, depth of field, and other photographic considerations. While many filters can be used in a camera's programmed-automatic mode, others require the ability to set the camera's aperture (aperture-priority mode), shutter speed (shutter-priority mode), or both (manual mode). It's important to be familiar with these operating modes to get the most out of this book.

To get the most out of the information on software filters, it is essential that you have a recent Mac or Windows computer. You will also need an image-editing program that is compatible with traditional Adobe plug-ins and should be familiar with the software. These programs include Photoshop, Photoshop Elements, JASC Paint Shop Pro, Corel Paint Shop Pro 10, Corel Photo Paint (included in Corel Draw), and Ulead PhotoImpact. A few of the techniques involve using Photoshop itself, and I'll walk you through them if you have the program, or suggest an alternative if you don't.

MAC OR WINDOWS

Either a Mac or Windows computer will do for most of the filters I'll address in this book. The major software filter companies, such as Auto FX Software, Nik Software, and Andromeda, support both platforms, as do most of the others, including Digital Film Tools, PixelGenius, and PowerRetouche.

There are a few digital filters that are Windows-compatible only, including a couple of interesting and inexpensive sets from Chroma Software and a free set from optikVerve Labs called Virtual Photographer. I'll make note that these are Windows-only filters as I discuss them.

While the majority of commercial photographers and advertising/design professionals prefer Macs, the vast majority of consumers use Windows-based machines. I use both, but prefer Windows, so most of the screen shots will be from my Windows computer. However, I'll throw in a few Mac screen shots just to show I'm not playing favorites.

If you plan on using software filters extensively, load up your computer with as much RAM as you can afford. Most of the filters use RAM exclusively to process the effect, so the larger the image you are processing, the more RAM you will need. Even with images in the 20-megabyte range, it can take a minute or so to render the image with some complex filters.

All of the filters display their effect on a small preview or proxy of the actual file. This is helpful and speeds up the process, but some of the previews are too small or too low resolution to rely on. The filter sets from Auto FX are the best in this regard. While the interface takes a little getting used to, the software runs full screen, even in plug-in mode, and generates a large proxy image. Multiple effects can be added in layers and, when you are satisfied with the image, you simply render it.

EQUIPMENT CONSIDERATIONS

Camera. Unless you are interested in shooting digital infrared images (see chapter 10), the specific camera brand or model of digital camera you are using isn't as important as its features and capabilities. There are several camera features that are nice to have. One is the ability to stop the lens down to its taking aperture so that the effect of the filter can be previewed and evaluated. This is important for a number of different types of filters. Another is the ability to spot meter different areas of the scene. Both capabilities will be discussed when they are needed.

Lens. Likewise, the brand of the lens is not critical. What's important when using some of the filters being

covered, however, is the way the lens focuses and zooms (if it does). While it differs from lens to lens, with modern lenses the front of the lens often rotates when it is focused or zoomed. Some autofocus zooms rotate the front when zooming but not when focusing; others rotate the front when focusing but not when zooming. With many special-effects filters and all polarizing filters, the rotation of the front of the lens has a direct impact on the filter effect. With these lenses, it's important to compose and focus before aligning the filter.

Filters will allow you to make subjective, interpretive, and corrective changes to your images . . .

Metering. Also, through-the-lens (TTL) meters built into cameras can sometimes be fooled when strongly colored filters are used. It's a good idea to have a handheld exposure meter along, and be familiar with its operation.

Tripod. Finally, a good-quality tripod is important for optimum results. The loss of light resulting from the use of some filters requires longer-than-normal exposures. A tripod eliminates the most common problem in photography: blurred images due to camera movement.

TECHNICAL INFORMATION

As I mentioned, I've included an appendix with a wealth of information about the technical aspects of light, the electromagnetic spectrum, and digital sensors for those of you who want more information in those areas. However, there is no need to completely understand the technical intricacies to enjoy the creative aspects of using filters on your camera or in postproduction to enhance your photos. Filters will allow you to make subjective, interpretive, and corrective changes to your images to satisfy your creative vision. Digital imaging provides an opportunity to make these changes both during the picture-making process and later, after the image has been downloaded to a computer. This book will explore the use of filters, both camera and software types, in hopes that it will inspire you to use them to achieve your vision.

I.
CHOOSING A CAMERA FILTER SYSTEM

Once you start using filters on your camera and begin to understand the creative freedom they give, you will become as addicted to them as I have. One, then a few, then it's more, more, more. (I have a Lowepro backpack full.) So it's important to get started with a system that not only serves your immediate interest but will meet your future needs as well. Camera filters are a major financial investment, and choosing the right system will save you time and frustration later.

SCREW-IN OR SLIDE-IN

There are two general types of camera filters, those that screw into the threads on the front (or drop into a slot on the rear) of the lens and those that slide into a holder attached to the front of the lens.

SCREW-IN FILTERS

If you own a limited number of lenses, or the ones you own all take the same size filter (which is unlikely these days), or if you plan on just using one type of filter (a

There are two general types of filter systems for digital SLRs: filters that slide into a holder (right) and those that screw directly into the lens (left).

If the filter or filter holder intrudes into the field of view of the lens, as shown here, the corners of the image will appear dark. This effect, called vignetting, occurs most often when filters are used on wide-angle lenses. Filter manufacturers make ultrathin filters to eliminate this problem.

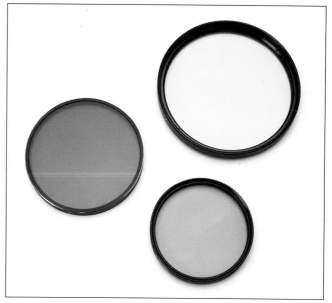

Screw-in filters come in a variety of sizes to fit most lenses. However, if you own a variety of lenses with different front diameters, it may be necessary to buy the same filter in different sizes.

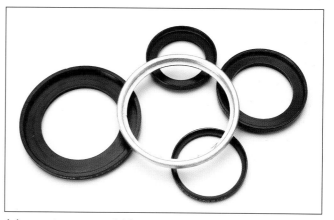

Adapter rings are available to convert larger diameter screw-in filters to smaller-diameter lenses. However, this increases the possibility of vignetting with wide-angle lenses.

polarizer or an enhancing filter), then screw-in filters are definitely the way to go. The best screw-ins, those from Heliopan, B+W, Tiffen, and Hoya's Pro 1 Digital Series, come in a wide variety of sizes. They are multicoated to minimize ghost reflections and are generally thin enough to be used on even very wide-angle lenses without vignetting. (Vignetting, a darkening at the edges of the photos or even a black circle at the perimeter, is caused by the filter or filter holder extending into the field of view.)

The main advantage of top-quality, screw-in filters is that they are made from optical glass (see below). This makes them resistant to rough handling, easily cleaned, and of extremely consistent quality. Screw-in filters, however, are only available in a fairly limited range of types.

While it is possible to buy one glass filter with a diameter that is large enough for the largest diameter lens in your kit and carry adapters to "step up" the smaller diameter lenses to fit that filter, this can be challenging. Modern manufacturing technology allows for the production of high-quality, large-aperture (f/2.8) zooms of 2x or more range—and these feature large front diameters of 62mm to 77mm or greater. Many photographers own slower, even wider-range zooms with 52mm front filter diameters. As you can imagine,

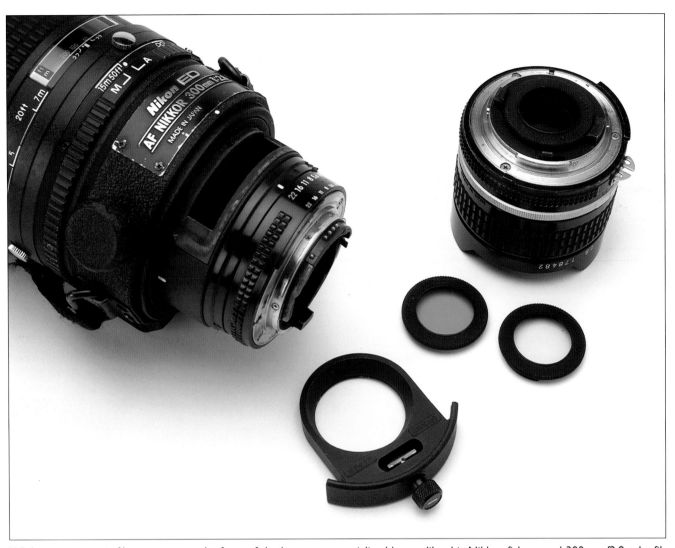

While most screw-in filters mount on the front of the lens, some specialized lenses, like this Nikkor fisheye and 300mm f2.8, take filters that either screw in or drop into the rear of the lens.

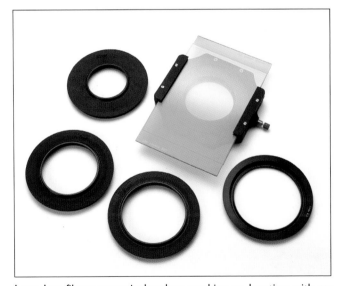

I use Lee filters extensively when working on location with my digital cameras. I have one filter holder and the adapter rings shown, along with the filters.

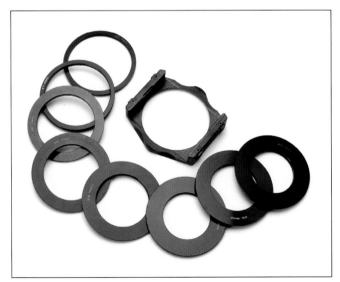

I have used Cokin filters for many years, both in the studio and on location with film and digital cameras. I own a large number of Cokin adapter rings, several filter holders, and many filters.

trying to assemble a screw-in filter system for this wide a range of lens diameters—while avoiding vignetting with wide-angle lenses—is a daunting task, and mistakes can be very expensive.

SLIDE-IN FILTERS

By far the most versatile system for camera filters is one of the slide-in systems. As with screw-in filters, choosing the right slide-in system means looking at the lenses you already own, and also thinking about those you would like to own—both in terms of their front filter diameter and their focal length. Again, vignetting can be a problem with slide-in systems and wide-angle lenses, just as it can be with screw-in filters that are adapted down for wide-angle lenses.

The advantage of slide-in filters is that, with careful planning, you only need to buy one set of filters and one filter holder, then relatively inexpensive adapters for each different lens filter diameter that you own. Getting started with the right filter and filter holder size is the trick.

Filter Sizes. *67mm (2.6-inch) Filters.* The smallest and least expensive of the slide-in filters are the Cokin A series of 67x71mm filters. These are available in the widest variety of types, with 192 different filters currently available. Cokin offers adapters for lenses that take 36mm to 62mm filters.

The A-series filter holder provides four slots: three for rectangular filters and one for a rotating filter. This type of filter holder allows multiple rectangular filters to be used in combination and to be used along with a rotating filter such as a polarizer.

The size of the filter limits their use to lenses with a focal length of 35mm or more on a full-frame digital SLR (or about 24mm on a less-than-full-frame digital SLR). While this may be fine for the lenses you currently own, be sure to consider the possibility of future lens purchases.

It is possible to adjust the position of slide-in filters to place the transition anywhere in the frame, or at an angle, as shown here. Positioning the Lee neutral-density (ND) 2-stop graduated filter parallel to the horizon would have darkened the top of the hillside. Positioning it at an angle parallel to the hillside darkened only the sky, which is what I wanted.

84mm (3.3-inch) Filters. My largest collection of slide-in filters is the 84mm Cokin and Lee P series. Adapters are available for 48mm- to 82mm-diameter filter threads. I have not experienced any vignetting problems on my Nikon digital SLRs down to a 17mm focal length. P-series filters should be usable on full-frame digital cameras down to 24mm lenses.

Cokin makes 187 different P-series filters, all of them 84mm square. The Cokin P-series holder, like the A-series folder, has four slots. Three of these are available for square or rectangular P-series filters and one for a rotating filter.

Several other companies manufacture filters that fit the Cokin P-series filter holder. Lee's P-series filters are 84x120mm and consist primarily of graduated filters and a few warming filters. Singh-Ray's graduated filters are available in 84x120mm for the Cokin P-series holder, and the company also makes some very interesting enhancing filters (see chapter 7) in the 84mm square size. Tiffen makes a number of graduated filters, including several 84x165mm neutral-density graduated filters (often called "ND grads") made from glass rather than optical plastic. Hitech also makes graduated neutral-density filters in the P-series size, although they are more difficult to find.

AN ADDED ADVANTAGE . . .

The advantage of rectangular graduated filters is the ability to move the beginning point of the gradation anywhere in the image with a wide-angle lens without danger of seeing the edge of the filter.

100mm (4-inch) Filters. Filters of this size and larger are only really needed by photographers using extreme wide-angle lenses with digital SLRs. Cokin supplies a Z-Pro filter holder with adapters for filter threads from 49mm to 96mm and four slots, like their A- and P-series holders. There are 89 different Cokin filters in this series. Some are 100mm square while others are 100x150mm (4x6 inches).

Lee has an even wider range, with more than two hundred different filters, available in 100mm square or 100x150mm rectangular sizes. Also available from Lee is a filter holder with slots for three filters. Standard adapters are available for filter threads from 49mm to 112mm. Recessed wide-angle adapters are available for 49mm to 82mm filter sizes.

I own both standard and wide-angle adapters and use them regularly with the Lee filter holder. I prefer the Lee system when using graduated filters because the holder rotates smoothly in the adapter but can also be locked down with a setscrew once it is properly positioned.

The disadvantage to the Lee system is the lack of a slot for a rotating filter, such as a polarizer. The 105mm Lee polarizer must be attached to the front of the filter holder with a special ring that allows it to be independently rotated. With some lenses, this could lead to vignetting. Lee also makes a 100mm-square polarizer that can be used in the rotating holder if you are not using another filter that must also be aligned in a certain way, such as a graduated filter.

Singh-Ray also makes a range of filters in 100mm. In general, filters from any manufacturer can be used interchangeably in any filter holder.

FILTER MATERIALS

All filters are not created equal! That's one reason for the large price differences between filters that are seemingly the same. While higher-quality professional filters generally cost more than mass-produced consumer filters, price alone shouldn't be the deciding factor when selecting from a number of supposedly similar filters. At times, the least expensive filter may actually be the correct choice; other times, nothing but the best should be considered.

Owning a variety of filters represents a sizable investment, so knowing something about the types of materials from which filters are manufactured is important in making the right choices. Filters are manufactured from four types of material: gelatin, polyester, resin, and glass. Each has its advantages and disadvantages, and there are variations in quality within each type and between manufacturers.

Gelatin. By far the greatest range of filters is available in gelatin. Gelatin filters have been available for so long and in such a wide variety that the term "gel" has become synonymous with "filter." Gelatin filters are made by dissolving precisely formulated dyes in liquid gelatin and coating the solution onto prepared sheets of

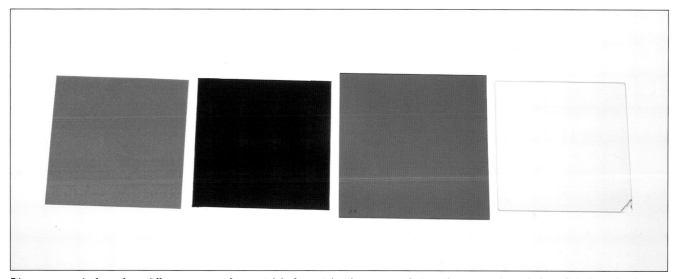

Filters are made from four different types of material. Left to right, these are: gelatin, polyester, resin, and glass. Gelatin and polyester filters are available in 3-inch and 4-inch squares. Resin filters are generally designed as part of a slide-in system, often with a proprietary size, and may be square or rectangular. Glass filters are the most durable and come in a variety of sizes to screw into the lens.

glass. After the coating is dry, the gelatin film is stripped from the glass, coated with lacquer, and cut to size. Prepared in this manner, gelatin filters have a thickness of 0.1mm (±0.01mm). Because of their uniform thickness and the precision of the manufacturing process, gelatin filters are least likely to degrade image quality—at least while they're still new.

Unfortunately, gelatin filters require the greatest care in storage and handling. The thin lacquer coating offers only limited protection, so they must be handled extremely carefully by the corners or the edges. They also must be cleaned carefully. Dust and dirt particles should only be removed by blowing clean, dry air from an aerosol can across them. Any remaining particles should be removed by gently brushing with a soft, dry, clean camel's-hair brush. Wiping with a cloth will cause tiny scratches that degrade image quality.

When not in use, gelatin filters should be stored in a dry, cool environment, in their original packaging. High humidity can cloud the gelatin. Even under ideal storage conditions, the dyes, like all dyes, can change over time. Gelatin filters that are used frequently need to be replaced periodically.

Gels are sold unmounted in 75mm (approximately 3 inches) and 100mm (about 4 inches) squares, so they require a frame and holder for mounting the filter in front of the lens. There are many types of frames and holders on the market as shown to the right.

When I use one of my 75mm gelatin filters, I mount it in a Cokin gel holder, which slides into one of the slots of the Cokin P-series filter holder. With this system, I am forced to use a focal length greater than 17mm on my Nikon digitals to avoid vignetting.

Some manufacturers eliminate the handling and storage problems of gelatin filters by creating a sandwich of the gel between two pieces of glass. This combines the precision of the gelatin filter with the ruggedness of a glass filter. When carefully manufactured with clear, high-quality glass and properly sealed against moisture, this type of filter is an excellent choice—

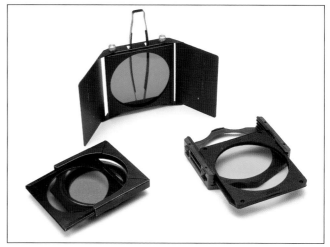

Gelatin filters are the least expensive filter, but they are also the least durable. They require a filter frame and holder for mounting on the lens. A number of manufacturers provide these frames and holders.

though considerably more expensive than the pure gelatin filter. Every glass polarizing filter is made this way.

Polyester. Filters made from high-quality, polyester-base materials to which dyes have been added are rapidly replacing gelatin-based filters for all but the most precise scientific applications. Polyester filters are available in a wide range of types at a reasonable cost. They are tough, impervious to moisture, and easy to clean—though care should still be taken to blow off dust with canned air as a first step in any cleaning process. Like gels, polyester filters are usually sold unmounted in 75mm or 100mm squares, so they also require frames and holders for use.

Filters will allow you to make subjective, interpretive, and corrective changes to your images . . .

Resin. Cokin first popularized acrylic resin filters as special-effects filters in the 1970s, but they are now available in a wide range of filter types from numerous manufacturers. Unlike gelatin and polyester filters, resin filters do not need to be one solid color; they can be manufactured with clear areas graduating to color or one color graduating into another.

Resin filters can take much rougher treatment than gelatin or polyester, yet are lightweight for their size. Given the same care as camera lenses, these filters will last for years. The best resin filters are made of CR39 organic glass, which is a lightweight and unbreakable optical material also used for ophthalmic eyeglasses.

Glass. Glass filters, other than the least expensive ones, are made from optically clear glass (called water glass) that has been dyed while molten, then cooled and cut into cylinders. The glass is ground with both surfaces perfectly parallel to one another and mounted in a ring that accurately aligns the filter surface parallel to the front lens element.

Like quality lenses, the finer glass filters have antireflection coatings. This eliminates ghosting and flare in photos taken with strong backlighting or with a bright light source at the edge of the frame.

Antireflection coatings allow the filter to transmit light more efficiently than glass alone. Uncoated glass filters transmit only 92 percent of the light that enters them. Some of this lost light is refracted and reflected on the surfaces of the glass, reducing contrast and causing ghost images. A single layer of antireflection coating, however, cuts the amount of non-image-forming light in half. Multiple layers allow for the transmission of as much as 99.7 percent of the incident light, allowing only 0.3 percent to potentially reduce image quality. Interestingly, the most important surface for multicoating is the final surface of the filter, the one closest to the first element of the camera lens. Some manufacturers multicoat only this surface, then use just a single coating on the surface facing the scene; others multicoat both surfaces. Expect to pay significantly more for multicoated filters.

Hoya has designed a line of Pro1 Digital Filters especially for digital cameras. Each filter is multicoated and mounted in a thin aluminum frame with a black satin finish. Even the edge of the glass is rimmed in black to reduce the chance of light reflecting from an edge.

While some multicoated filters also have a final anti-scratch coating, care must still be taken when cleaning them. Clean, dry canned air will remove loose particles, followed by a light brushing with a camelhair brush. A gentle wipe with a soft lens tissue or one of the new microfiber cleaning cloths will remove any stubborn dirt. Lens cleaning solutions should not be used on these filters (or on multicoated lenses) as they may damage the coating by creating permanent streaks on the glass surface.

Using a multicoated glass filter is a particularly good idea if the filter is going to be on the lens all the time, such as a UV (ultraviolet reducing) or skylight (ultraviolet reducing and warming) filter. Glass filters, except for some polarizers and some extremely thin designs made for extreme wide-angle lenses, have a screw thread on the mount. This allows for the attachment of additional filters or the appropriate lens shade.

FILTER FACTORS

Because many filters work by absorbing some part of the visible spectrum, less light is available to the image sensor, so exposure must be increased when filters are used. This exposure increase is called the filter factor. The table below gives f-stop adjustments for common

filter factors. As various filters are covered in this book, their filter factors are given for reference. Note that when multiple filters are used simultaneously, the filter factors for the individual filters are multiplied, not added, to obtain the final exposure correction.

F-STOP INCREASE REQUIRED FOR FILTER FACTORS

FILTER FACTOR	EXPOSURE INCREASE (STOPS)
I	0
1.2	$^1/_3$
1.4	$^1/_2$
1.5	$^2/_3$
2	I
2.5	$1^1/_3$
2.8	$1^1/_2$
3	$1^2/_3$
4	2
5	$2^1/_3$
6	$2^2/_3$
8	3
10	$3^1/_3$
12	$3^1/_2$
16	4
32	5
64	6

LENS SHADES

Adding filters in front of the lens increases the possibility of lens flare from light outside of the angle of view of the lens. Using a lens shade (or hood) minimizes flare. Even multicoated lenses can benefit from the use of lens shades. However, shades do not come without their own issues. Shades supplied by lens manufacturers are designed to end just outside of the lens field of view. Adding a filter or two and then replacing the lens shade can lead to vignetting, visible at the edges of the photo as a dark circle.

With gelatin, polyester, and resin filters, this can be eliminated by using an adjustable lens shade, also known as a compendium, with rear slots to hold the filters. These are available from a number of manufacturers. Compendium lens shades that attach to the tripod socket or incorporate a camera grip rather than attaching to the front of the lens are also available. These eliminate the problem of having the filter holder

attached to a lens on which front section rotates. Many of these compendiums have slots where square or rectangular filters can be inserted.

With glass filters, a shade designed for a slightly shorter focal length than the lens can be used if it has the correct diameter to screw into the filter. Otherwise it is possible to buy aftermarket lens shades of different depths, depending on the focal length of the lens and the filter-mount size.

In the next chapter we will look at color balancing and correction filters, and whether they are needed in light of the controls available on digital cameras.

2.
COLOR-CONVERSION, LIGHT-BALANCING, AND COLOR-COMPENSATING FILTERS

One of the tremendous benefits of digital cameras is their ability to produce pleasing color under a wide range of lighting conditions—from daylight, to incandescent, to fluorescent. But does this mean that you no longer need to use color-conversion (80- and 85-series), light-balancing (81- and 82-series), or color-compensating filters (such as CC30 Magenta for cool-white fluorescents) over the lens while shooting? As you will see, the answer is a qualified "Yes." You don't really *need* these—as long as you are shooting in RAW mode and don't need absolutely accurate color right out of the camera.

DIGITAL IMAGING

White Balance. The red, green, and blue micro-filters used on digital sensors (see appendix) only correct for a very narrow range of red, green, and blue. Think of all the colors that you call "red," and you'll see the prob-

LEFT—Not every scene needs a neutral color balance. This image contains daylight, fluorescent, and incandescent light sources, so I just set the white balance on daylight and shot to see how it would look. I liked the result. **FACING PAGE**—Digital cameras allow photographers to color balance for different types of light sources while you shoot. In most cases, this works well. These color charts were all shot under controlled conditions in my studio and saved as JPEGs in my Nikon D1X. I then moved them into my computer and, using the Photoshop Curves eyedroppers, I set the white, black, and gray points of the white, black, and midtone gray to the same values, letting the colors fall as they would. With luck, the differences in color will hold up in printing.

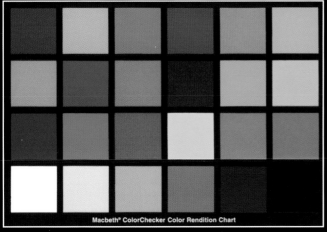

Macbeth® ColorChecker Color Rendition Chart

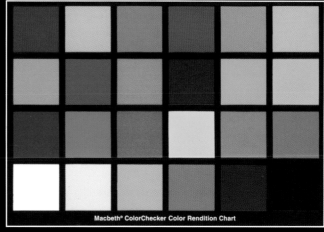

Macbeth® ColorChecker Color Rendition Chart

The first example was taken with the camera set to the daylight white balance with studio flash that very closely matches the color temperature (5200K) of the DIX's daylight setting. This is the most accurate color rendition of the color chart.

The second chart is slightly warmer because of the difference in color temperature of the flash white-balance setting in the DIX. This was taken with the same studio flash unit but with the DIX's white balance set to flash.

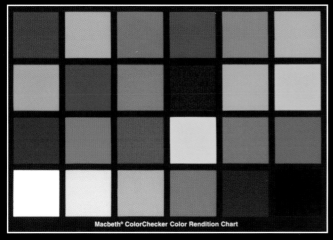

Macbeth® ColorChecker Color Rendition Chart

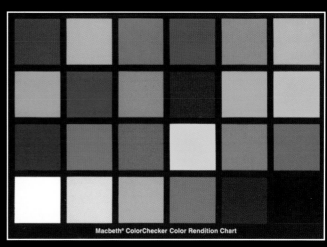

Macbeth® ColorChecker Color Rendition Chart

The DIX, on the fluorescent white-balance setting, does a good job with the cool white fluorescent lights in my studio, as you can see here.

Colors suffer, however, under incandescent lighting. This is because the DIX uses 3000K for this setting, rather than the 3200K of my studio lights.

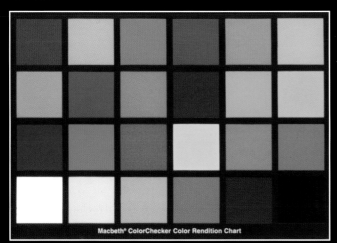

Macbeth® ColorChecker Color Rendition Chart

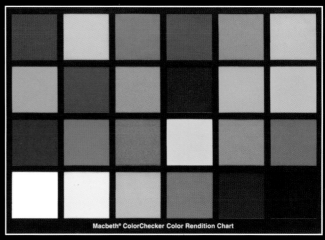

Macbeth® ColorChecker Color Rendition Chart

Here, the colors are much closer to the first reference chart. I created this image using the DIX's daylight white-balance setting and an 80A color-conversion gelatin filter with the 3200K lights.

Next, I omitted the 80A filter, set the DIX to daylight, and shot with 3200K lights. Then I tried to correct the JPEG in Photoshop. As you can see in this color chart, only the white, black, and mid-tone gray patches are the same as those on the other charts—and this is thanks to Photoshop.

lem. So engineers select filters for each of the three colors that work well with daylight and electronic flash, since the majority of photos are taken with those light sources.

Correcting for cloudy and shade conditions isn't too tricky and works well since the correction is fairly minor and involves using less of the blue channel, which always needs the most amplification. Correcting for incandescent and fluorescent lighting, however, involves large changes. Incandescent lighting in particular is tricky as it requires a major increase in the blue channel (think of an 80A filter that corrects 3200K [Kelvin] light to daylight balance). Correcting fluorescent light is also tricky for the engineers, since there are a number of different types of tubes, and they all change color at different rates as they age.

Correcting for

cloudy and shade conditions

isn't too tricky and works well . . .

I recommend avoiding the automatic white-balance (AWB) setting, particularly if the lighting conditions are tricky. Shooting in AWB can give a slightly different color balance with each capture, even when the lighting conditions don't change. This is because digital sensors are much more sensitive to color-balance changes than we are. Shooting in one of the preset modes (sunlight, shade, cloudy, etc.), on the other hand, locks in a color balance. If you need to covert or correct the images later, you can do it in a batch once you determine the correction needed.

Fortunately, with a combination of camera and software filters, you can correct images made with nearly any light source to a neutral color balance. And if neutral isn't what you're looking for, you can use hardware and software filters to achieve that look, too.

File Format. *RAW Format.* When you shoot digital, I recommend using the RAW capture mode. Even though this means capturing fewer images on each media card and additional time later to process the images, the advantages outweigh the inconveniences. When you shoot in the RAW mode, you can use the manufacturer's conversion software to change from one preset to another, achieving the same result that you would have obtained if you had set the camera to that preset.

For example, imagine you are working in the sunlight, making RAW captures with the sunlight preset. Then you move indoors and forget to change the preset. As a result, when you view the RAW images on the computer screen, they will have a yellow cast from the incandescent light. To correct the problem, you can go to your RAW conversion software and simply select incandescent as the correct color balance for these images. The yellow cast will be minimized—exactly as it would have been if you had remembered to reset your camera to incandescent *before* you took the pictures.

JPEG Format. But what if you are shooting JPEGs and do this? Now you have a problem, since the manufacturer's software will likely be of little help. Making the conversion in an image-processing program like Photoshop is tricky, time-consuming, and will often leave big gaps in the histogram.

Fortunately, there are two solutions for JPEG shooters. The first is to use a conversion filter over the lens (of course, if you could remember to do this, you could remember to change the preset on the camera!). The second solution is to use a software filter to correct the color balance after the shoot. An advantage of the software filter, besides not having to purchase and carry a hardware filter, is that it requires no increase in exposure when shooting.

In either case, to use them correctly, you will need to know a little about the way these color-conversion filters are numbered.

COLOR-CONVERSION FILTERS

Filter Designations. If you capture JPEG images in daylight with the incandescent white-balance setting, they will look blue, unless one of the 85 series of amber filters is used. If they were taken with incandescent lights with one of the outdoor settings, they will look yellow unless you use one of the 80 series of blue filters to correct the photo. Later in this chapter we will address fluorescent light filters and correcting for shade and overcast on a sunlight white-balance setting.

85 Series. When shooting at the incandescent white-balance setting, the three filters of the amber 85 series

(85, 85B, 85C) only need to remove some of the blue present to convert daylight to the proper balance. The 85C filter gives the least warming, followed by the 85, then the 85B, which gives the most. The 85B is the one to choose most often, though even more correction may be needed.

80 Series. The four filters of the 80 series (80A, 80B, 80C, 80D) balance the color temperature of incandescent light sources if one of the daylight settings was used by mistake. The 80A, which converts incandescent theatrical stage lights to daylight balance, is a good place to start, as it is the strongest of the four. But even it may not be enough if the light sources are household bulbs. The 80B gives less correction than the 80A, the 80C less than the 80B, and the 80D the least of all.

Both the 80- and 85-series filters can be used in combination, either on the lens or in software.

Digital Options. If you are using Photoshop CS or CS2 or Photoshop Elements 3.0, you will find that Adobe has built in an 80 filter and an 85 filter. These can be applied directly to the image by going to Image>Adjustments>Photo Filter (Photoshop) or Filter>Adjustments>Photo Filter (Elements). Better yet, in Photoshop you can apply these filters on an adjustment layer by going to Layer>New Adjustment Layer>Photo Filter.

My favorite software plug-in program for color-conversion filters is the Color Conversion tool in the 55mm collection from Digital Film Tools. To covert the image using the Color Conversion tool you must have it open in your favorite image-editing program. When you select the 55mm collection from your Filters or Effects menu, the full list of 55mm filters is displayed. When you choose Color Conversion, a preview image opens in the 55mm window, with a drop-down menu

of filters and a row of sliders beneath. The sliders allow you to adjust the opacity of the filter, the overall exposure, and the amount of color in the highlights. You

The 55mm collection from Digital Film Tools includes many filters in its dropdown menu. I chose Color Conversion to make the large change in color temperature that was needed for this wedding photo taken in mixed lighting with the daylight white-balance setting on my digital camera.

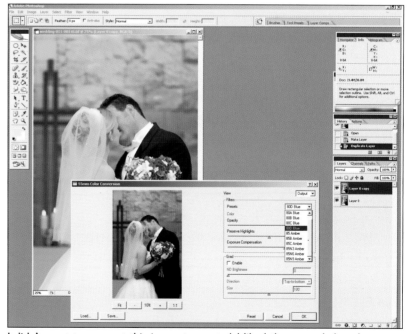

I didn't want to correct this image to neutral. I liked the warmth, but there was too much red in the groom's face. The 55mm filter interface has a drop-down listing of the color-conversion filters. The 80D worked well with this image, leaving some of the warmth while reducing the excessive red in the groom's face. Later, a Curves correction could improve the contrast and make any other slight correction in color.

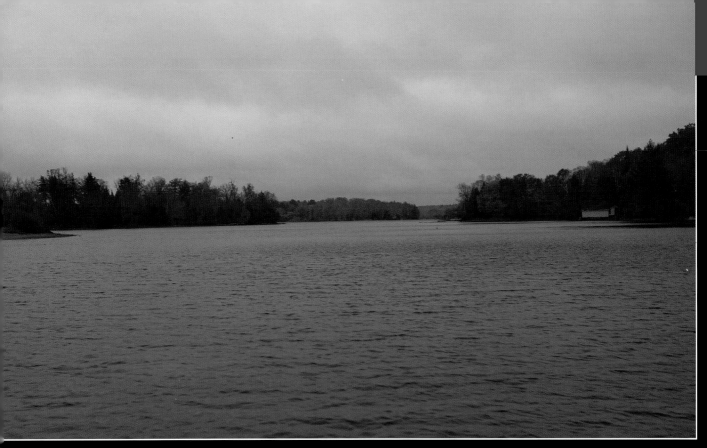

The D1X delivered the above rendition of heavily overcast early morning on a lake in Canada. To me it felt colder than this so I added an 80A filter to produce the image below. The canoeist was a bonus.

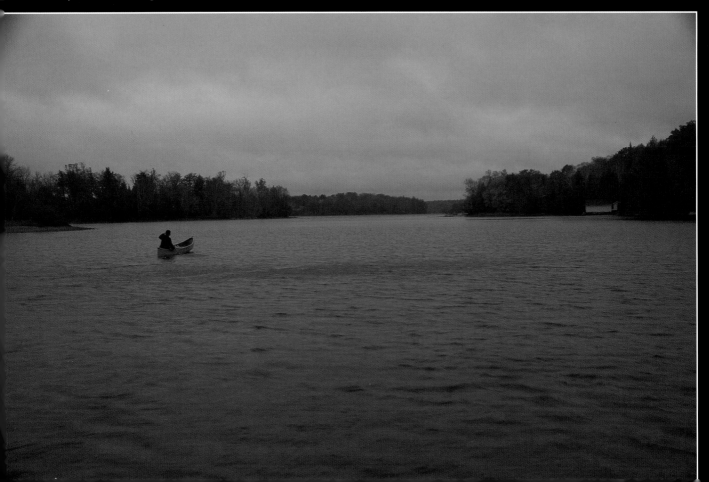

simply choose the filter, adjust the sliders until it looks good in the preview, and apply the filter by hitting OK. There is even a drop-down menu that allows you to toggle between the original image and the filtered version.

When applied as described above, the Photo Filter tool in Photoshop creates an adjustment layer automatically, but many plug-ins, including the filters in the 55mm collection, do not. When using these strong software filters, or any software filters for that matter, be sure to duplicate the image you are working on to a new layer *before* applying the filter. That way, you will always have the unfiltered image to return to if you decide you don't like what you have done.

Creative Applications. While color-conversion filters were created for specific technical purposes, their use as creative tools is what draws many photographers to them. The strong effect that color-conversion filters have on light makes them appropriate as mood enhancers in photography. For example, heavily overcast and foggy days keep most photographers at home. But these types of days are perfect for shooting with a blue 80A filter over the lens (or later on the computer) to create a moody, monochromatic, otherworldly effect.

Indoor scenes with incandescent light don't need to be corrected back to neutral. In many cases, the warmth of the scene can be an important element of the photo. Using an 85-series filter in your image-editing software will enhance the warm mood that using an incandescent white-balance setting will minimize.

Warming filters are also useful for enhancing sunset photos. While other filters specifically designed for this purpose will be discussed in chapter 4, any of the 85 series of color-conversion filters will add significant warmth to the sky as well as the foreground. This effect is strongest in the midtones and shadows and the overall, nearly monochromatic effect serves to tie the sky and foreground together to produce a feeling of "sunset" rather than simply a photo of a sunset.

LIGHT-BALANCING FILTERS

Like color-conversion filters, light-balancing filters are designed to adjust the color temperature of the light. The adjustment they offer, however, is much smaller. These are the filters to use for moving back and forth between the sunlight, shade, and overcast white-balance settings.

Filter Designations. There are two series of light-balancing filters, the bluish 82 series and the straw-colored 81 series.

82 Series. The cooling 82 series has four members: 82, 82A, 82B, and 82C. This time the numbering is logical, with the 82 giving the least correction and the 82C the most. These filters are effective in reducing some of the excess red in late-afternoon sunlight, minimizing the ruddy "sunburned" look seen in front-lit portraits taken during this time of day.

In many cases, the warmth of the scene can be an important element of the photo.

81 Series. There are six members of the 81 series of warming filters: 81, 81A, 81B, 81C, 81D, and 81EF. These, too, progress logically in degree of correction from the 81 with the least to the 81EF with the most correction.

Some digital portrait and fashion photographers find the warming effect of the straw-colored 81 series so appealing that they use one, usually an 81 or 81A, on their lens at all times to warm up flesh tones. Both of these filters add a pleasant warmth to portraits taken indoors or out. The 81B, 81C, and 81D filters are also useful for this, but their effect is more visible if there are obvious neutral colors in the photo.

Where the important elements of a composition are entirely in open shade or lit by an overcast sky, the 81EF filter eliminates the cool blue cast and yields a warm, natural-looking skin tone. This is the hardware filter that the camera manufacturer tries to duplicate with the shade white-balance setting.

Combining Filters. Additional shifts in color temperature can be accomplished by combining filters within each light-balancing series or in combination with color-conversion filters. The most common use of light-balancing filters in many applications is for noticeable warming and cooling. Since their effect on color temperature is so much less than color-conversion filters, the warming and cooling is far more subtle.

The left photo was taken in open shade using the daylight white-balance setting with a Kodak DCS Pro SLR/c. As a result, it is too blue. Using the 81EF filter setting in the 55mm Light Balancing plug-in set, I quickly enhanced it to the version on the right.

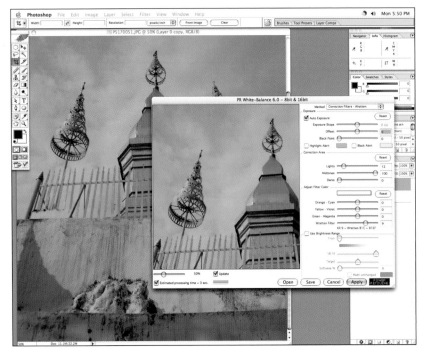

The White Balance set in the PowerRetouche plug-in provides a Wratten Filter setting with some, but not all, of the Wratten light-balancing filters. You are also able to target the correction to light, midtone, or dark values—and even to a limited number of colors of the spectrum. Once you become familiar with the interface, the amount of control you have is tremendous.

Software Options. In software, Photoshop CS, CS2, and Elements 3.0 or greater include an 81 and 82 filter, but for the full set, the 55mm collection from Digital Film Tools is, again, the best choice. The 81 and 82 series filters are found in the Light Balancing set. Remember to duplicate the original image to a new layer before applying the filter.

Another plug-in, PowerRetouche, has combined many, but not all, of the color conversion and light-balancing filters with other tools in its White Balance set. Choosing the Wratten Filter option from the drop-down menu at the top of the screen activates this option. A slider lets you select the available filters. There are also sliders to allow you to fine-tune the color of the filter. With the Wratten Filter set to zero, these sliders allow you to change the overall color in every imaginable way.

PowerRetouche White Balance even provides a slider that gives you control over the range of gray values that are changed by the color adjustment, effectively creating a luminosity mask. You can correct a range of highlights with one application, a different range of highlights with another application, on down through the full range of gray values. This is a very powerful tool with many possible options, and it can be overwhelming until you experiment with it for a time. Fortunately, the preview window is very helpful in showing the results of your experiments.

Creative Applications. Used creatively, light-balancing filters, like color-conversion filters, impart an overall "mood" to a photo, but to a lesser extent. Both types can be used to link the foreground and background. In doing so, they tend to reduce overall contrast by producing more of a monochromatic look.

COLOR-COMPENSATING FILTERS

Both color-conversion and light-balancing filters adjust the proportion of yellow/red to blue/cyan in the light, either absorbing blue/cyan or yellow/red. Their effect is fairly broad across the visible spectrum. Sometimes, however, it is useful to target more specific areas of the spectrum, because imbalances can occur in the propor-

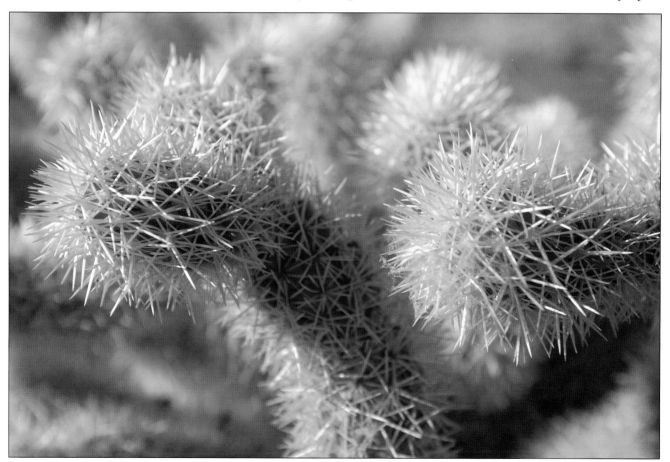

Cholla cactus are grayish-green in real life, but a green color-compensatring (CC30G) filter adds some color and life to them.

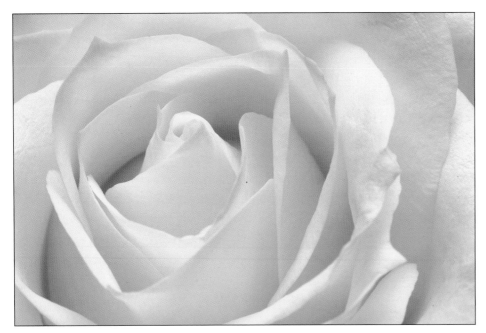

A strong color-compensating filter can be used to change the color of a subject if there are no other critical elements in the shot. Here a white rose (top) is changed into a pale yellow rose (bottom) with the use of a CC50Y filter over the lens. This could easily be done in software as well.

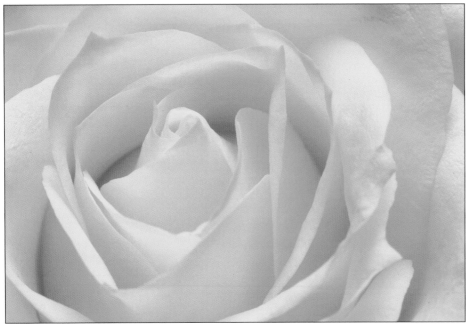

tion of all components of incident light. These imbalances are corrected by color-compensating filters, which can also give a photographer precise control over the creative color rendering of the subject.

Filter Designations. Color-compensating (CC) filters are available in seven strengths, in both the additive (red, green, blue) and subtractive (yellow, magenta, cyan) primary colors. From weakest to strongest these are: 025, 02, 10, 20, 30, 40, and 50.

Filter Materials. For use on the camera lens, color-compensating filters are usually purchased as gelatin or polyester because many photographers carry a large

number of them. They are also available in resin or glass from some manufacturers.

Creative Applications. If you are shooting JPEGs or even RAW images with cool-white fluorescent lighting, using a CC30M (color-compensating 30 magenta) filter will give you a more color-balanced original than using the fluorescent white-balance setting in most digital cameras.

The stronger color-compensating filters can be used much like the color-correction or light-balancing filters to create "mood," or an almost monochromatic effect by tying the foreground and background together with

Less intense color-compensating (CC) filters are appropriate if you want to subtly increase the saturation of a particular color. This is done by using a CC filter close to the color of the subject. The yellow rose (top) was enhanced with a CC20Y filter to produce the result on the bottom.

color. The range of colors is far greater, however, with color-compensating filters.

Stronger filters are also effectively used to increase the color saturation in a monochromatic photo. Taking a close-up photo of a white rose with a CC50Y (color-compensating 50 yellow) filter will add color to the flower and minimize any small color defects it might have, as shown on the facing page.

Similarly, the weaker color-compensating filters can be used to subtly intensify a color by using a filter the same color as the subject. You can also subdue a color by using a complementary filter. In either case, the filter will have little effect on the highlights and shadows. As in the example above, the color of a pale yellow rose will seem more intense when photographed with a CC20Y filter, or even paler with a CC10B, but the fence will still look white to the eye.

Digital Options. Color-compensating filters are available as software filters also, and again the 55mm collection from Digital Film are the best. All of the colors, from the weakest density to the strongest, are included. To my eye, they function just like their hardware equivalents. Just remember to duplicate your image to a new layer before applying the filters.

OTHER COLOR-BALANCE OPTIONS AND TOOLS

Filtering the Light. Professional photographers not only use filters on their lenses, they also use them over their lights to warm or cool the light. With this method, the light on a subject can be warmed, and the light on the background can be cooled. No filter is used over the lens, eliminating the chance of flare reducing the image quality. The most popular filters for this purpose are Rosco Color Temperature (CT) gels. Blue (B) is used to cool the light, and orange (O) is used to warm the light. They come in varying strengths—⅛, ¼, ½, ¾, and full.

Software Options. In their PhotoKit Color series, PixelGenius includes CTB (color temperature blue) and CTO (color temperature orange) filters in all the strengths listed above. In Photoshop, the PixelGenius filters are accessed via the File> Automate menu. When you apply them, they create a new layer for the filter, like a Photoshop adjustment layer, so the original image remains untouched. You can then create a layer mask for the filter and apply it anywhere you choose.

Colored Reflectors. Portrait photographers often use a reflector opposite the main light. This board could be white for a diffuse fill with the same color temperature as the main light, gold for a warm look on the shadow side of the face, or silver, for a brighter, harder quality.

Software tools that replicate these looks are available in the Digital Film Tools 55mm and Nik Color Efex Pro 2.0.

The Gold Reflector in the 55mm collection opens a preview image and provides sliders to adjust the effect.

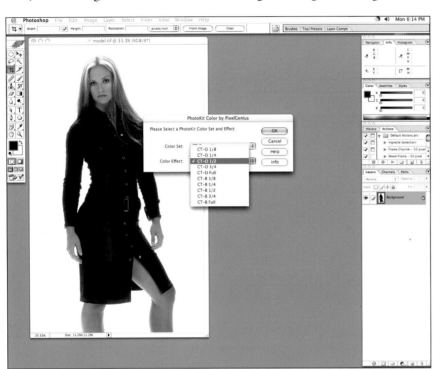

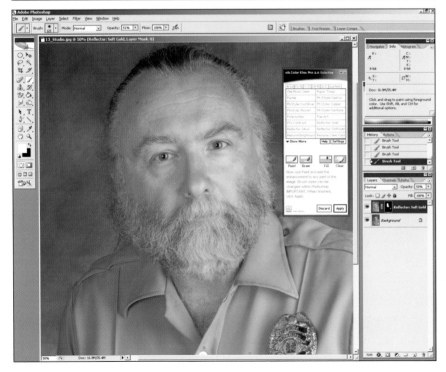

TOP—The PhotoKit Color series of plug-ins from PixelGenius operate from the File>Automate menu in Photoshop. Included are the equivalent of Rosco Color Temperature (CT) filters that studio photographers put over their lights to increase or decrease the light's color temperature. **BOTTOM**—Using the Selective feature of Nik Color Efex 2.0 Pro, you can brush on effects simulating the use of silver, gold, or soft gold reflectors in Photoshop. This screen capture shows the image after the Soft Gold Reflector has been applied to the shadow side of the model's face and to the gold badge.

While it does add warmth to the shadows as a gold reflector board would, the filter adds more warmth to the highlights than I like to see.

I personally prefer the Gold, Soft Gold, and Silver Reflectors from Nik—but only when they are applied in Photoshop through the Selective feature (File>Automate>Nik Color Efex Pro 2.0 Selective), which allows you to apply the effect as needed using a layer mask. If you are a program other than Photoshop, you will need to apply them globally from the Filter menu.

Wallace ExpoDisc. There is another device on the market that I have found very useful when I need to create an accurate or slightly warm white balance while shooting. It is the ExpoDisc, which is available as a screw-in filter, for lenses with standard filter diameters from 49mm to 82mm, or as a slide-in for the Lee filter holder.

With the ExpoDisc, you can leave your meters, gray cards, and color charts at home. This patented device allows you to accurately determine exposure and white balance in a few simple steps and, once these settings are stored in your digital camera, to capture images without worrying about these settings until the lighting conditions change.

The simplicity of the ExpoDisc is striking. It consists of a neutral, prism-textured plastic disc on one side and a neutral plastic diffusion disc on the other. Sandwiched between the two are color-conversion filters. There are two versions of the ExpoDisc: the Digital White Balance Filter that gives a neutral color balance and the Digital Warm Balance Filter that gives the warmth of an 81EF filter.

For neutral white balancing, each unit is individually calibrated to ensure that incident white light (light whose red, green, and blue components are present in equal amounts) is transmitted through the filter with equal red, green, and blue (RGB) values emerging on the other side. With the ExpoDisc mounted over the lens under the intended shooting conditions, the white-balance software in the camera reads the RGB values of the light transmitted by the ExpoDisc and, if they are not equal, makes a corresponding adjustment to equalize them. The Warm Balance Filter works the same way, but its slight blue bias fools the camera's white balance, producing a setting that warms the images captured.

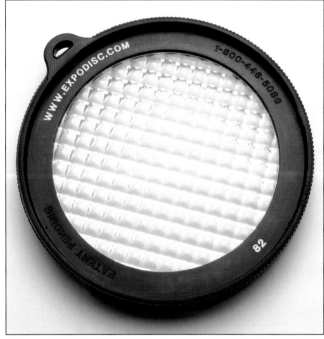

When you need a neutral color balance, even in mixed lighting, I have found no better tool than the ExpoDisc. By placing it over the camera lens and using the camera's custom white-balance tool, you quickly and easily balance the digital sensor to whatever lighting conditions exist.

The exact procedure for this white-balance process varies from camera to camera. The instruction sheet packaged with the product gives general procedures, and the ExpoDisc website (www.expodisc.com) gives specific steps for different camera bodies. Essentially, however, all you need to do is to perform a custom white balance with the ExpoDisc over the lens, save the result as a preset, and start capturing images.

If you're shooting JPEGs, the ExpoDisc will give you extremely accurate color correction, either neutral or warm balance. For those photographers shooting RAW files, the ExpoDiscs are equally valuable. Simply make a capture or exposure through the ExpoDisc and use this frame as your reference for white balance in postproduction (or for the photo lab to use to gray balance the proofs). ExpoDiscs are truly useful, versatile, and highly recommended.

3.
POLARIZING FILTERS

FOR THE CAMERA

For many photographers, a polarizing filter is the first filter they buy after one to protect their lens. There is an excellent reason for this: no other filter is as useful in improving a photo. No travel or landscape photographer should leave home without one.

How They Work. When light is scattered or reflected, it becomes polarized. To better understand what this means, it is necessary to understand more about the nature of light.

Although light is more accurately described as packets of energy called photons, it's possible to simplify the theory and think of light as waves. To relate light to everyday experience, picture a long rope tied to a ring at one end. If the free end is picked up

I consider a polarizing filter to be an essential tool for any photographer who travels. It heightens the contrast between the sky and clouds, eliminates reflections from the surface of water, and increases the saturation of foliage—as can be seen here. The image at the top was taken without a polarizer, while the one on the bottom was shot with the polarizer on the lens.

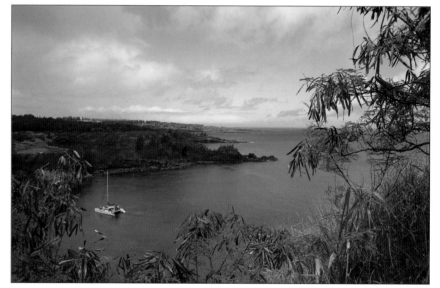

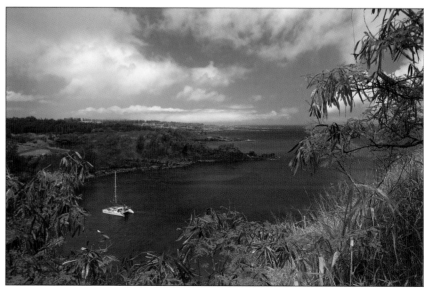

This scene (right) is an ideal candidate for a polarizing filter, either on the camera or in software. In this case, I used the Polarizer in Nik Color Efex Pro 2.0 to create the final result (below). Photo by Amelia Sholik.

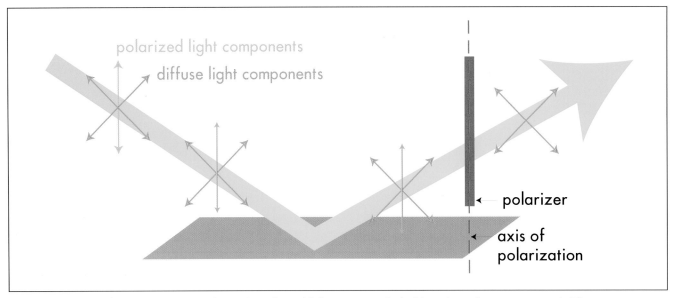

When unpolarized light strikes most surfaces, the reflected light consists of a highly polarized component and diffuse components. When the axis of polarization of the polarizing filter is perpendicular to the polarized light, this component is eliminated. This allows the diffuse components of the light to pass and be recorded.

and shaken up and down in a line, a series of waves move down the rope to the far end. In a similar way, light moves in one direction, as a series of waves, and the distance between the tops of consecutive waves is called the wavelength.

However, there is a major difference between light and the rope: light vibrates randomly in all directions perpendicular to the direction of its travel. When this randomly vibrating light is scattered, some of it ends up vibrating more strongly in one plane than in all others, much like the rope example. This scattered light is said to be polarized.

This is where polarizing filters come in. These filters are made up of grid-like foil cemented between two pieces of glass. The foil is designed so that only light waves vibrating parallel to the grid of the foil are transmitted. Those rays vibrating perpendicular to the grid are completely blocked, and vibrations in other directions are partially blocked. Eliminating this polarized light allows you to reduce or eliminate reflections on many surfaces and create images with increased contrast and saturation.

Types of Polarizing Filters. There are two types of polarizing filters made for photography: linear and circular.

Linear Polarizers. Before TTL metering, autofocus, and autoexposure cameras, all photographic polarizers were the linear type, consisting of a foil of polarizing material between two sheets of glass.

Circular Polarizers. Today's digital SLR cameras rely on a beamsplitter to send part of the light entering through the lens to the meter and autofocus mechanism and part to the viewfinder. Because of the beamsplitter, light entering the meter and autofocus sensors is partially polarized. In this type of system, when a linear polarizer is placed over the lens it acts a second polarizer, blocking light to the meter in amounts depending on the angle between the beamsplitter and the polarizing filter. As you can imagine, this creates exposure and autofocus problems.

By adding another foil of precisely the right thickness behind the linear polarizing foil in the filter, circular polarizers change the linear polarization into an orientation that, to the camera, appears to be unpolarized. Going back to the rope example above, if the free end of the rope is moved in a circle, circular waves will travel down the rope. This is what circularly polarized light is like.

While this eliminates exposure and autofocus problems, it adds to the cost of the filter—as well as adding another piece of material between the scene and the film, potentially resulting in image degradation. If the light reading is done with a handheld meter, the filter factor applied (see pages 16–17), and the camera expo-

sure and focus set manually, there is no reason why linear polarizers cannot be used even when the camera manufacturer recommends otherwise. On the other hand, circular polarizers are backward compatible; they also work fine with earlier model cameras.

Sizes and Multicoating. Both types of polarizing filters are available from many different manufacturers in screw-in sizes from 46mm to 82mm. By their nature, polarizing filters do not benefit from a single layer of antireflection coating; multicoating, however, particularly of the exposed rear surface, is beneficial. The PL-CIR (circular polarizer) made by Hoya is one that features a multicoated rear element.

Additional Options. Both B+W and Hoya make a polarizer with a skylight filter incorporated into it for a slight warming effect and increased haze penetration. Hoya fits theirs into a 5mm rotating ring, making a slim

package for use with wide-angle lenses where vignetting may occur when individual filters are stacked together. Also available for wide-angle lens users are polarizers from other manufacturers in ultrathin mounts to avoid vignetting.

B+W sells a specialized polarizing filter called a Kaesemann polarizer. Available in both linear and circular types, this extremely high-quality filter has the internal foil(s) stretched and held under tension in all directions so that the material is perfectly flat. Additionally, the glass is of the highest quality and all surfaces are exactly parallel. The edges are totally sealed so that it is unaffected by moisture and fungus. The advantage is a slightly greater polarizing effect and minimal image degradation with fast telephoto and apochromatic lenses (lenses corrected so that red, green, and blue wavelengths come to a common focus).

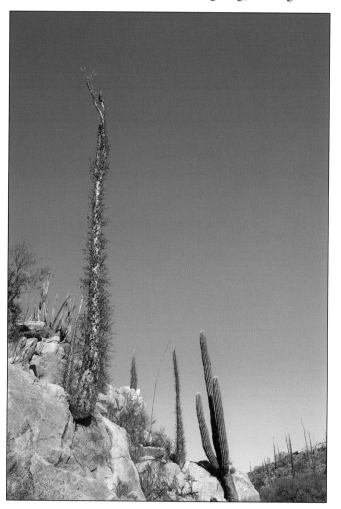 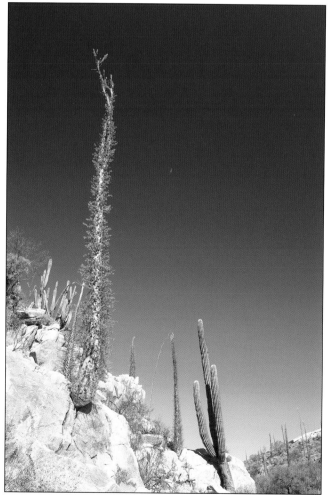

I travel with a Cokin polarizer that slides into the Cokin holder slot closest to the lens and allows complete freedom of rotation. There is no vignetting, even with the wide-angle lenses on my Nikon digitals. Polarizing filters can turn rather ordinary photos, like this of a tall boojum tree in Baja, California (left), into something much more interesting (right).

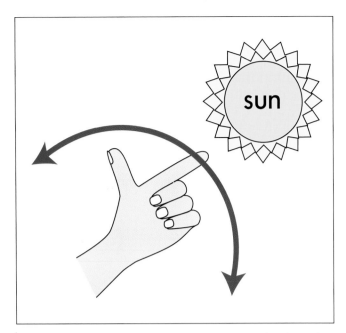

To determine what part of the sky will be darkened with a polarizing filter, point at the sun with your index finger. Raise your thumb perpendicular to your index finger and rotate it. The arc made by your thumb is the area of the sky where the polarizer will have the greatest effect.

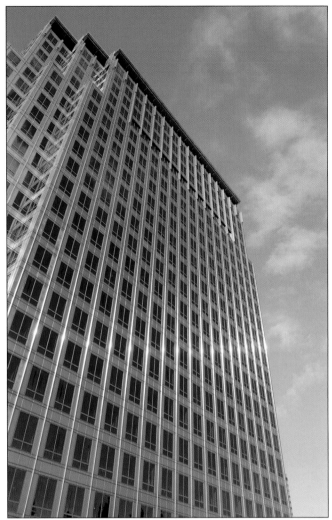

ABOVE AND FACING PAGE—Polarizing filters have no effect on reflections from unfinished metal surfaces. No matter what the sun angle, reflections from this stainless-steel building (above) are unchanged, although the polarizer darkens the sky behind the building (facing page).

Until a few years ago, if you needed a polarizing filter, you had to buy a screw-in type. Then Cokin introduced their slide-in polarizer, which is now available in both linear and circular polarizing types for all of their holders. It slides into a thin slot in the Cokin holder designed specifically for a rotating filter, and the arrangement works very well.

Lee Filters also makes a 100x100mm circular polarizer that slides into their holder, but the entire holder must be rotated to use it. They also make a 105mm round circular polarizer that fits into a holder that attaches to the front of their filter holder so that it can be rotated independently of other filters.

When to Use a Polarizing Filter. While most photographers think of a polarizing filter as a means of darkening the blue sky on a sunny day, there are many other uses. These include reducing reflections in windows, reducing or eliminating the sky reflection in water, and even increasing the color saturation on overcast days.

When using polarizing filters for landscape photography, it is possible to control the saturation of the sky from virtually unchanged to deep blue, depending on the placement of the sun in the sky. The maximum effect will occur in that part of the sky that is 90 degrees from the sun. To visualize where this area is without looking through the polarizer, point in the direction of the sun with your index finger. Raise the thumb of the same hand until it is perpendicular to the index finger and rotate the hand. The circle that the thumb makes in the sky will be the area where maximum darkening will occur.

Increasing the saturation of the blue sky has an additional benefit—it increases the contrast of the sky and clouds. Under some conditions and light angles, it is actually possible to eliminate some of the clouds from the sky! Remember, clouds are white because they scatter all wavelengths equally, but the light we see is still scattered light and, therefore, polarized. Therefore, it's

possible for the polarizer to eliminate them partially or completely.

Light can also become polarized when it is reflected from some surfaces. When light strikes a rough-textured surface, its random nature is not affected, and the surface is called diffuse. Unfinished metal surfaces also have no effect on the random nature of light waves, so a polarizing filter will do nothing to eliminate the reflection of the sun off of a stainless steel building. In between these two extremes are numerous surfaces, including glass, water, wood, grass, leaves, and many others, from which the reflected light is at least partially polarized. The degree of polarization depends on the angle of incidence of the light and varies from material to

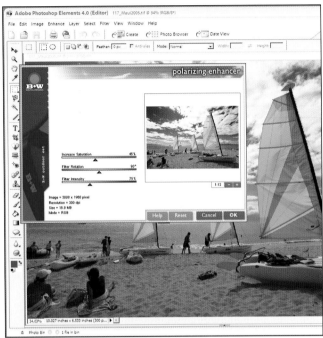

The Polarizing Enhancer (left) in B+W's Outdoor Set has sliders to vary the rotation angle of the filter, increase the filter intensity, and increase the saturation of the image. Before (below) and after (bottom) examples of the image are shown.

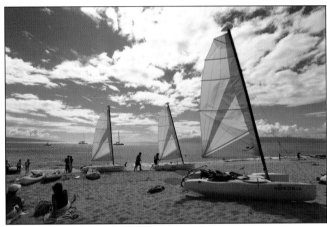

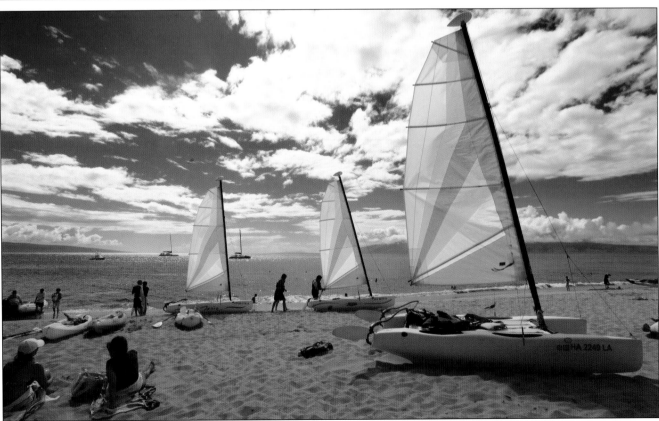

material. Light reflected off water has a maximum polarization of just less than 37 degrees, while maximum polarization of light reflected off glass is about 32 degrees, depending on the type of glass. Under ideal conditions, reflections can be completely eliminated when the angle of the light to the surface and the angle of the camera lens to the surface are almost equal and in the range of 30 to 40 degrees.

Filter Factor. Polarizing filters increase contrast and saturation by eliminating light that has been polarized by the surface and strongly reflected. This makes it possible to photograph the weaker diffuse reflection off the surface. The cost is a loss of about half of the visible light, requiring an exposure increase between 1½ and 2 stops (filter factor of 2.5 to 4). This exposure increase is constant no matter what angle the polarizing filter is turned to or the degree of reflection reduction. The filter factor does vary, however, depending on the filter manufacturer and the shooting conditions. Built-in meters in digital cameras will compensate for this light loss provided you use a circular polarizing filter when metering.

A polarizing filter on your camera won't produce any polarization effect if the subject has a diffuse surface like this Protea blossom (top). However, a software polarizing filter (here, Nik's Polarizer) will increase the contrast and saturation (bottom).

FOR THE COMPUTER

Given the popularity and versatility of a polarizing filter when taking pictures, it should be no surprise that they were one of the first camera filters to be found with a digital counterpart. While many programs offer a digital polarization filter, I have only found the offerings from B+W and Nik Software to be really effective—and even those will not produce the same results as using a polarizing filter on the lens in many cases.

Digital polarizing filters are most effective when they are used to darken a blue sky and increase sky/cloud contrast. They work best with a clean horizon line, or where the sky is selected, with the Magic Wand tool for instance. In the Outdoor Set from B+W, the Polarizing Enhancer plug-in has sliders to vary the rotation angle of the filter, increase the filter intensity, and increase the saturation. With only a smallish "after" preview of the effect, it is a little difficult to see the result, but the filter applies quickly to the full image. The polarizer in Nik Color Efex Pro 2.0 has only a rotation and strength slider, but the presence of before-and-after previews makes it easier to visualize the changes before you apply them. The effects are similar from both companies.

Both the Nik and B+W polarizers also very effectively increase the contrast and saturation in photos taken in shade or under overcast skies. With their simple controls

Software polarization filters work great with many subjects, but they won't remove reflections from windows, shiny metal, or the surface of water like hardware polarizers. I shot the left image without a polarizing filter, then used my Cokin polarizer on the lens for the right image.

it is much quicker and easier to see if they produce an effect you like than it is to use several complex controls in an image-processing program.

Where the software polarizers won't help you is in eliminating reflections from windows, shiny metal, or water. Saturation and contrast will increase, but the reflections will remain. In these instances, only a polarizing filter over the lens will help.

Where it is possible to eliminate a lot of filters from your camera bag, as we will see in the next chapter on graduated filters, I feel that a polarizing filter is essential for every photographer to carry wherever they may go.

The Polarizer in Nik Color Efex 2.0 (Filter>Nik Color Efex 2.0: traditional filters) offers only two controls, rotation and strength, but the before and after previews make it easy to see the result of varying the sliders.

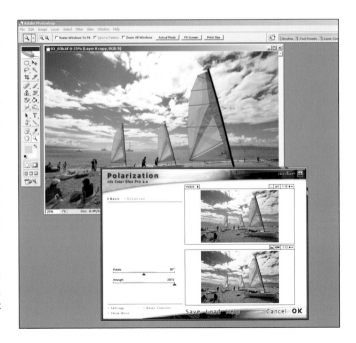

GRADUATED FILTERS

When shooting outdoors, you will often find that the best exposure for the foreground is not the best exposure for the sky. With the foreground properly exposed, the sky is washed out; with the sky properly exposed, the foreground is too dark.

With a digital camera, it is always best not to overexpose, so you must expose for the sky and spend time on the computer bringing up detail in the foreground. While this is one option, there is a problem with it. Since the foreground is underexposed, as you lighten it up you accentuate the noise that is always present in underexposed areas. And since the subject you are photographing is probably in this foreground area, you are degrading the quality of the image of the subject.

This is less of an issue if you are capturing images in RAW mode. Most RAW conversion software allows you to hold detail fairly well in the highlights and shadows when you process the image to a TIFF or JPEG. However, if you are shooting JPEGs in the camera, or just prefer to get it right while you are shooting, then neutral-density graduated filters (often called "ND grads") are the answer. And if you decide, after seeing the image on the monitor, that you should have used a ND grad, there is still hope with software ND grads.

But graduated filters both for use on the camera and in the computer aren't limited to neutral density. In fact, the most interesting graduated filters are the color grads, especially for use in postproduction. Let's look at both ND grads and color grads for use on the camera and in the computer.

NEUTRAL-DENSITY GRADUATED FILTERS

For the Camera. Neutral-density graduated filters are primarily designed to darken the sky in landscape photos. Many types are available, although all have a clear area over part of the filter and some degree of neutral density over the other. They are numbered on a logarithmic scale, with the most common densities being 0.3, 0.6, and 0.9. These reduce the exposure by 1, 2, and 3 stops respectively. The most useful of these for landscape photography are the 2- and 3-stop filters.

The most interesting graduated filters are the color grads, especially for use in postproduction.

Hard vs. Soft Gradations. With "hard" grads, the transition between the clear and neutral-density sections is abrupt. This type of filter is commonly used when there is a distinct horizon separating the foreground and sky. These filters reduce the light almost immediately, right at the horizon, where it is often the brightest close to sunset.

"Soft" grads, on the other hand, don't reach their full density until about two-thirds of the way out of the frame of a full-frame SLR. While this type is more for-

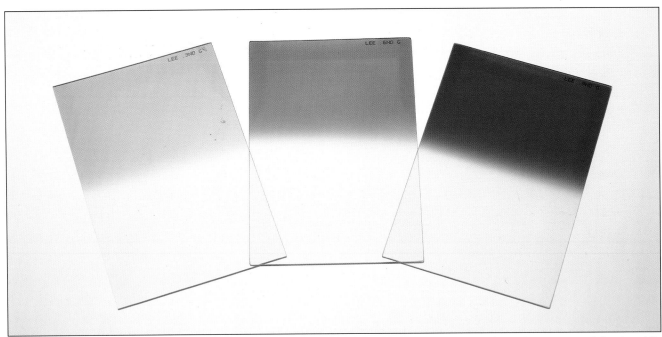

Slide-in ND grads, like these from Lee filters, give you a lot of options for positioning the transition from clear to neutral density while taking a photo. The densities shown, from left to right, are 0.3 (1 stop), 0.6 (2 stops), and 0.9 (3 stops).

giving and easier to use, if the bright area of the sky is close to the horizon you tend to lower the filter too far, darkening some of the foreground in the process.

With full-frame digital SLRs, both of these types are useful, depending on the situation. With cameras with smaller-than-full-frame sensors, the best choice would be a set of the "hard" grads, where the transition is abrupt. By the time a soft grad reaches full density on this type of digital SLR, the area is very high in the frame.

The smoothness of the transition from clear to dark in the final photo depends on a number of factors. These include the design of the transition on the filter itself, the focal length of the lens, the distance of the filter from the lens, and the shooting aperture. Wide-angle lenses at small apertures will give a sharp transition even with softly graduated filters. Telephoto lenses used wide open may require a hard gradation on the filter for the darkening to be noticeable at all.

Filter Types and Alignment. Neutral-density grads with both hard and soft transition zones are sold as both screw-in and slide-in filters.

Round, screw-in ND grads rotate much like polarizing filters so that the transition can be adjusted to match the horizon. The disadvantage of this type is that the transition area is fixed, beginning in the center of the frame and moving outward, requiring you to place the

horizon close to the center of the photo. However, when round ND grads are used in combination with one another or with the round colored grads that will be discussed below, aligning the transition areas is easier than with rectangular grads.

The dark area of slide-in ND grads generally covers less than half of the filter area. These filters are much longer than they are wide and are designed so that the transition area can be positioned anywhere in the frame.

Aligning a slide-in grad can be a little tricky. While the clear and dark areas are quite obvious when the filter is off the lens, they are far less obvious once the filter is mounted. The best solution is to mount the camera on a tripod and, in manual or aperture-priority mode, stop the lens down to its smallest aperture with the depth-of-field preview button. (This is why it is useful to have this feature on your digital SLR camera.) Then, slide the filter to align it with the horizon. Release the depth-of-field preview button, set the camera to the proper exposure, and make the photo.

If your camera lacks a depth-of-field preview, position the filter as best you can. Then, make a trial exposure and preview it on the LCD screen. Zoom in as far as needed to check the alignment. Trying to hand-hold the camera and accurately align the filter to the horizon with the lens wide open is nearly impossible.

Metering. Choosing the right density grad and making the correct exposure can be tricky, too. It is best to use the in-camera spot meter or a handheld spot meter and set the exposure manually. One reading is taken of the foreground and a second of the sky, about halfway from the horizon to the highest point that will appear in the photo. If the difference between these readings is 2 stops, then a 2-stop (0.6) ND grad is a good starting point. More or less darkening can be accomplished with stronger or weaker filters. For the most believable result, the sky should still appear to be brighter than the foreground in the final image.

Usually, a 2-stop ND grad is the most that is required to bring the sky into the exposure range of the foreground, but there are exceptions. One situation would be when photographing in the cooled lava fields of Hawaii. In that situation, in order to hold definition in both the black lava and in the clouds I found a 3-stop (0.9) ND was needed.

Neutral-density graduated filters aren't only for darkening skies. They can be used equally effectively to darken reflections from the surface of a backlit lake by placing the graduated area over the foreground. This is a good option if you forgot your polarizing filter.

For the Computer. *Plug-in Filters.* While a number of software filter sets offer a neutral-density grad setting, I haven't really found one that gives me the kind of results that a camera filter gives for controlling the sky in a landscape photo. For one thing, if the sky is overexposed by 2 stops because your digital camera exposed the foreground properly, nothing is going to save it. Even a RAW capture would be tough to save with this amount of overexposure. For another, getting the transition properly positioned from no filter to filter is difficult in software. There are two software sets that get it pretty close: Nik Color Efex Pro 2.0 and the Photographic Filters from Chroma Software.

The pre-defined set that I find most useful is in Nik Color Efex Pro 2.0's traditional filters set, but it's not the Graduated Neutral Density filter. I prefer to select the Graduated User-Defined filter and choose a dark-gray value for the color. Sliders let you vary the density, blending, and vertical position, and the before and after thumbnails provide useful visualizations of the effect. You can even rotate the gradation if your horizon isn't level. (Better yet, rotate the photo so the horizon *is* level.)

I was happy enough with the Nik filter until I discovered the Photographic Filters from Chroma Software, available only for Windows computers. Their three sliders and a larger preview image make them a little easier to use. The Hardness slider can be controlled to a hard line. I do this first, then use the Offset slider to position it roughly where I want the transition. Then it's back to the Hardness slider to set the width of the transition. A final little tweak of the Offset slider positions it precisely, and an adjustment of the Strength slider sets the amount of neutral-density correction. A Zoom button aids positioning, and another slider rotates the filter up to 180 degrees in either direction.

ND Grad Effects without a Plug-in Filter. While these filters are useful in some situations, I've found that any imaging program that supports layers, blending modes, and masks provides a way to apply a neutral-density grad effect that is quicker, easier, and offers more control. Here's how.

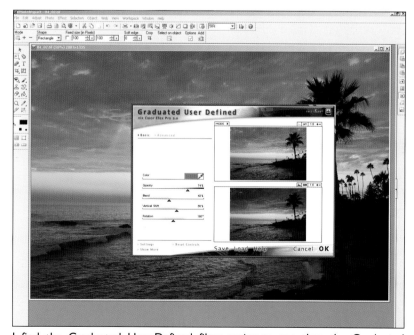

I find the Graduated User-Defined filter easier to use than the Graduated Neutral Density filter in the traditional filters set from Nik Color Efex Pro 2.0. Just choose a dark gray for the color.

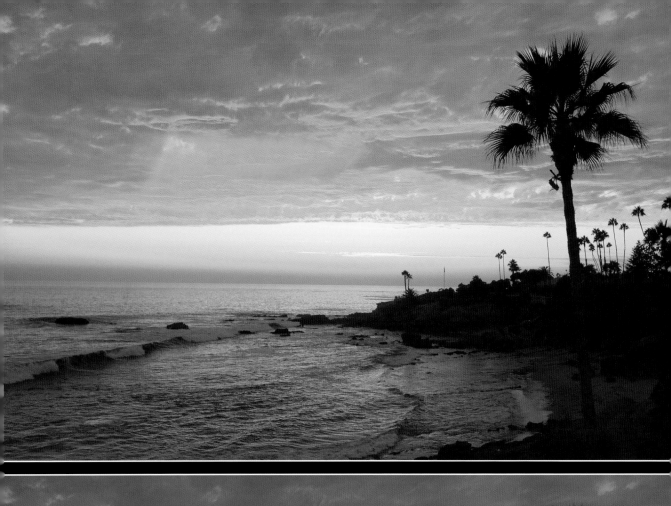
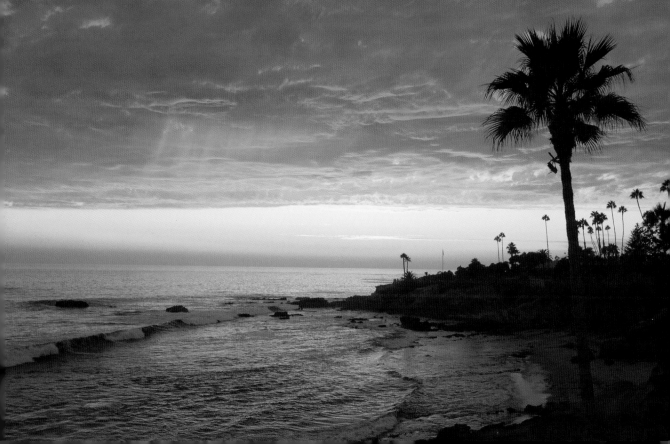

ABOVE—For Windows users, the Photographic Filters plug-in from Chroma Software has excellent controls for using any type of graduated filter, including ND grads—as long as you set up the color as a neutral gray. **FACING PAGE**—In the original capture (top), the sunset was a little too bright for me. Using the Chroma Software Photographic Filters plug-in with a neutral-gray grad at the setting shown in the screen capture above, I produced the result shown in the bottom image.

In Photoshop, for example, open the image and duplicate the background layer. In the Blending Modes drop-down menu, select Multiply rather than the default Normal. Then create a Layer Mask for this copy. With the foreground color set to black and the background color set to white, select the Gradient tool, and choose a foreground-to-background linear blur. With the gradient tool still active, click near the foreground, fairly close to the horizon, and drag toward the sky. If you don't like the effect the first time, just drag a different gradation until you do. If there is an object extending into the sky, you can eliminate effects of the ND grad filter on it by using a small brush and painting over it on the layer mask with black. If the sky still isn't dark enough, keep duplicating this layer with the graduated layer mask until it is. Save the layered file and you're done.

This same method can be used to darken any part of an image. For example, if one side of the image is in shadow and the other is in sunlight, the values in the sunlit area can be lowered to more closely match the shadows, and perhaps make a too-contrasty image print-

able. What it can't do is add density to an area that is significantly overexposed.

COLOR-GRADUATED FILTERS

For the Camera. While neutral-density grads can darken the sky in a landscape, colored grads can actually change an overcast gray sky to a rich blue—or mauve, or pink, or orange, or tobacco, or coral, or practically any other color imaginable. Purists will likely consider colored grads to be special-effects filters and wonder why I've put them here, rather than in chapter 8. The reason is, that, used sparingly and appropriately, they can subtly transform what might already be a *good* shot into a *great* shot.

First introduced by Cokin in the 1970s, color-graduated filters quickly found a market with advertising and automobile photographers. They allowed the introduction of color into the background or sky of the softly-lit images popular during that time. Location car and motorcycle photographers have used the tobacco grad to color the post-sunset sky

Cokin was the first manufacturer to produce graduated slide-in filters, like this Cokin Sunset grad, for still photographers. Cokin still produces them, now in three different series, as do Lee Filters and a few others.

behind the car to the point of it becoming a cliché. Unfortunately, many of these shots scream out "graduated color filter used here."

Cokin is still the leading proponent of color grads, with the widest variety available. I am particularly partial to their Sunset grads which, rather than having a clear section, graduate from a lighter to darker orange. Lee Filters also makes a very nice selection of color grads.

Colors and Uses. Many different colors are available, including blue, yellow, red, tobacco, pink, green, mauve, and more. Many of these colors are much too strong to be used, mainly because the color doesn't

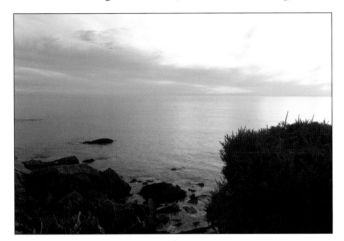

All ND grads and most color-graduated filters have a clear area, then an area of color. The two Cokin Sunset grads have an area of lighter orange and an area of darker orange, which is useful when shooting scenes such as the one on the top left where you want the foreground to carry some of the warmth of the sky. I used the lighter-density Cokin Sunset I filter to produce the result seen at the top right and a Cokin Sunset 2 to produce the image above.

ABOVE—Lee makes several Sunset graduated filters in sunset colors—yellow, orange, and red—with a clear filter area over the other half of the filter. This photo was taken with the Lee Sunset Red filter. RIGHT—Graduated filters can be combined to produce other effects. Here a Cokin Tobacco grad was used to warm the sky and a Cokin Blue 2 was employed to make the water a deep blue.

exist in nature. I admit to owning a number of different colors, but use them sparingly—almost as colored neutral-density filters—to enhance a similar color already in the scene, or at least a color that could have been there. Adding a warm orange cast to a sunset with Cokin's Sunset filter would be an example.

For a more subtle effect, color-graduated filters can be used to increase the color saturation in the area covered by the filter. Blue grads over blue water or to enhance a gray sky, sunset grads over a sunset sky, light chocolate or coral grads with autumn colors, pink stripe grads at the sunset horizon—these are just a few ways to

use these filters to intensify colors similar to their own, without calling attention to the fact that a filter was used at all. They are best used in simple, graphic compositions—silhouettes in particular—and in the paler tones to call less attention to themselves.

Graduated color filters are also used effectively with neutral-density grads where the ND grad is positioned to darken just the very top or very bottom of the area

covered by the color grad. Using offset complementary-colored grads has a similar effect, such as darkening just the upper portion of the blue-grad covered sky with a tobacco grad filter.

Positioning. Most color grads are rectangular to allow the transition area, which can be gradual or abrupt depending on the design, to be positioned anywhere in the frame. Positioning color grads is even more critical than positioning ND grads, since any small mismatch can add color where it isn't wanted or omit color where it is needed. Use the positioning techniques described in the ND grad section on page 40.

Exposure. Exposure is less critical with color grads than with ND grads, because the colored grads are generally much less dense. Metering with the camera's built-in meter will generally be fine. Only with a very

LEFT—Chroma Software's Photographic Filters interface gives Windows users the maximum amount of control over the color of the gradation as well as the hardness and position of its beginning and its overall saturation. **BELOW**—Applying the choices made in the Chroma plug-in gives this result.

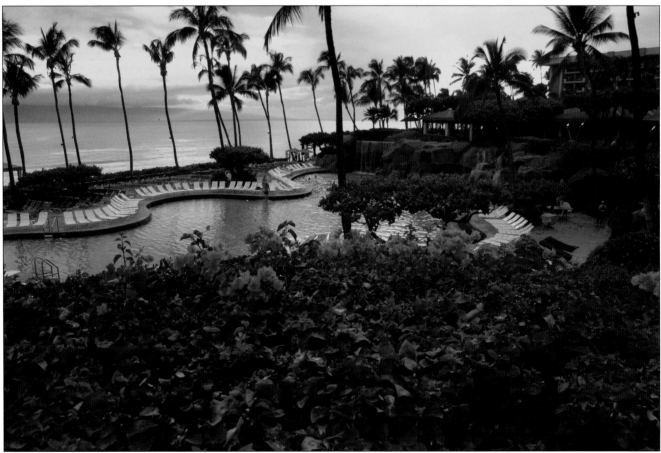

dense filter would you need to meter the foreground and set the exposure manually before shooting.

I have found that I use neutral-density grads far more often than color grads, so I would recommend purchasing a set of ND grads first, then color grads later. Or, perhaps the software equivalents will be all you'll ever need.

Colored Grads in the Computer. If using color grads appeals to you and you have a Windows computer, then the software you need is the Photographic Filters set from Chroma Software, the same set mentioned on page 41 for neutral-density grads. It contains the software equivalents of all of the colored grad filters from Cokin. The interface, as described above, allows a great deal of control over the hardness, strength, and position of the gradation. It also includes a color scale, so

Part of the inexpensive theimagingfactory plug-in for both Mac and Windows is a Graduated Color tool set. While it lacks an easy way to adjust the position where the gradation changes from clear to color, you can choose from any of the available system colors.

if you don't see what you like in the preset Cokin filters, you can click on the color scale, which opens up the Windows color picker. From here you can choose any color for your gradation.

It is even possible to have a gradation in one color going in one direction and a gradation of another color going in the other direction by applying the filter twice, with the second filter rotated 180 degrees from the first. Alternately, a graduated filter can be laid over a solid filter in the Chroma software.

The downside of these filters is that they will only act on the background layer. Once you apply the filter and save the file, the original file is permanently changed, so work on a copy if you want to keep the original.

Another option, this time for both Mac and Windows users, is the inexpensive Graduated Color plug-in from theimagingfactory. This set lacks the Cokin presets and the Hardness slider for positioning that are found in the Chroma set, but it does allow you to choose any available color in your system's color palette for the gradation. While it doesn't allow you much control over the positioning of the transition line from no filter to filter, this can be handled later with a graduated layer mask if your imaging program supports that.

Also available for both Mac and Windows users are the graduated plug-in filters in Nik Color Efex Pro 2.0, located in the traditional filters set. In the same software's complete set, there are four single-color grad presets (blue, coffee, olive, and orange) plus a user-defined filter. There are also five bicolor presets (brown, cool/warm, green/brown, moss, and violet/pink) plus a user-defined filter. Both user-defined filters include an eyedropper so that you can choose a color for the filter that is already present in the photo, as well as choose a color from the system color palette.

The Nik filters provide a Blend slider to control the blending of the filter color with the colors present in the image that works very well. There are also sliders to control the overall strength of the filter, the vertical position of the transition, and the angular rotation of the transition.

Similar results with any color gradation could also be obtained using a graduated layer mask within Photoshop, similar to the technique described on page 43. But having the filters available in presets, as they are in Chroma's Photographic Filters, is extremely convenient and encourages the kind of creative experimentation that color grads deserve.

5.
SOFTENING FILTERS: SOFT-FOCUS, DIFFUSION, AND FOG FILTERS

I've often wondered if lens designers ever wake up screaming and in a cold sweat, knowing that photographers are using soft focus, diffusion, and fog filters to knock back the sharpness they have spent hours of computer time designing into their lenses! And do other photographers ever pause for a second as they mount a plastic or polyester soft-focus filter before a portrait sitting and wonder why they spent all that money on an expensive lens in the first place?

We don't use these filters to drive lens designers crazy, we do it to create a mood, an atmosphere, and a sense of romance that really cannot be created any other way. While they are widely used in portraiture, they have a place in landscape photography as well. There is an entire school of Pictorialist photographers who use diffusion techniques in landscape work.

Filter manufacturers offer a wide selection of soft-focus, diffusion, and fog filters—and there is even a wider selection of software filters available. While there is a certain quality in an image taken with an expensive glass soft-focus filter, like the Zeiss Softar, that I have never seen duplicated in a software filter, there is cer-

Softening filters are most often used when photographing people. These examples show a few of the popular softening filters available from Tiffen (screw-in) and Cokin (slide-in). Model: Stephanie.

No filter.

Tiffen Black Pro Mist.

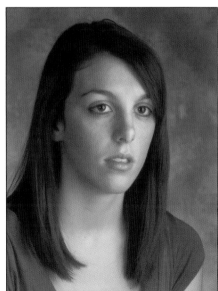

Tiffen Soft Net 3B.

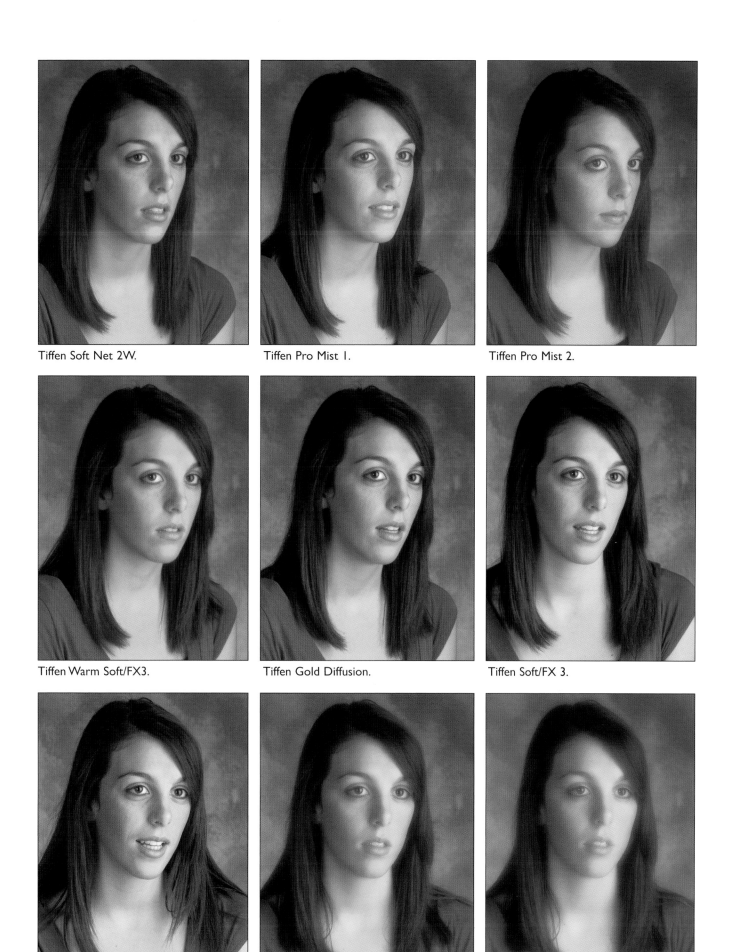

Tiffen Soft Net 2W.

Tiffen Pro Mist 1.

Tiffen Pro Mist 2.

Tiffen Warm Soft/FX3.

Tiffen Gold Diffusion.

Tiffen Soft/FX 3.

Tiffen Glimmerglass.

Cokin Diffuser 1.

Cokin Diffuser 2.

tainly much to be said for the variety of effects that software filters can achieve. Lets look at the options.

CAMERA FILTERS

Types of Filters. Softening filters can be grouped into four different types according to their design. The first type has a random pattern of waves, bubbles, dimples, or tiny lens elements in the filter. The second has a regular pattern of concentric circles or dimples. The third type has an overall texture to it, and the fourth has a net or random black pattern. Grouping softening filters by design and construction avoids the sometimes confusing and nonstandard designations of "soft-focus," "diffusion," and "fog" filters given by their manufacturers.

Filters with Random Elements. The first type of softening filters, those that incorporate random elements, achieve their effect by refracting some of the light passing through them. In order to better understand how this is done, it is important to understand how the lens forms a sharp image.

When light passes through glass, or most any light transmissive substance, it travels more slowly than when it travels through air. The speed of light in air divided by its speed in glass is the index of refraction of the glass. This index of refraction also measures how much the light is bent, or refracted, as it enters and leaves the glass.

When light enters a simple curved glass lens, the amount it is refracted also depends on the angle at which it strikes the lens. Light entering near the center of the lens is refracted less than light entering at a greater angle near the edge of the lens. The light that enters the lens near its edge is focused slightly closer to the lens than light entering near the center. This effect is called spherical aberration and is minimized in modern lenses by using lens elements of different shapes (concave and convex) in combination, or by using aspheric lens elements.

Spherical aberration can be left uncorrected or not fully corrected and produce an image with both a sharp

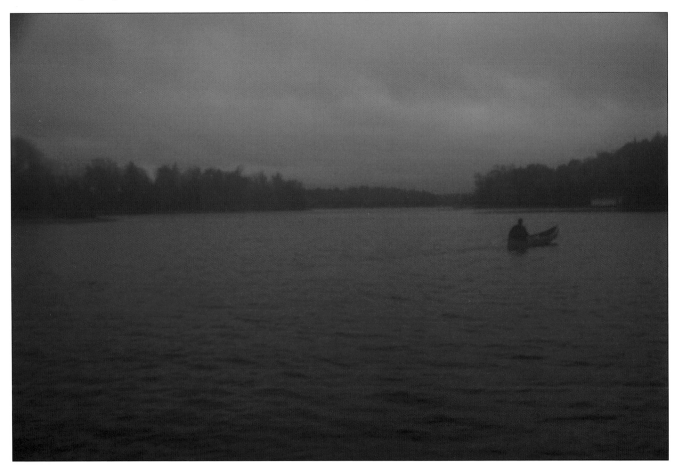

Combining a Cokin Fog 2 filter with an 80A adds to the cold early-morning feeling of this shot of the canoeist in Canada from chapter 2.

image and soft gradation throughout the image. This is exactly how portrait lenses available from some manufacturers are designed. The amount of softness is controllable by varying the aperture of the lens. As the lens is stopped down to smaller apertures, a greater proportion of the light entering through the center of the lens is used to form the image. As a result, the image is sharper than when the lens is used at maximum aperture.

It isn't necessary to invest in a specialized lens, however, to come up with a soft-focus effect. Some of the most popular types of soft-focus filters, those in the first group, are designed to give a very similar effect. The filter is clear glass or resin with a random pattern of tiny lens-shaped elements in it, looking like drops of water or a hammered surface. The clear areas allow light to pass and form a sharp image, while the rest of the filter refracts light to create a soft secondary image.

This type of filter was originally created by Zeiss and known as the Softar filter. Softar filters are still available from B+W as the Original Zeiss Softar 1 and 2. Hoya offers similar filters with its Softener A and Softener B and its Pro1 Digital Softon-A filter.

Other manufacturers have filters of this first type available with bubbles, dimples, waves, or other irregular patterns. The Hoya Diffuser filter achieves its softening by incorporating an irregularly uneven surface. The softening effect is most pronounced in areas of high contrast, is independent of aperture, and makes for much easier focusing with the lens wide open. Several strengths are usually available in each type of pattern.

Cokin's Diffuser Light, 1, 2, and 3 provide four different strengths of diffusion in a slide-in filter. I use the 1 and 2 when I am shooting portraits. This type is even available as flexible polyester filters. I use a Calumet Soft 1 (made by Lee) whenever I am doing a male portrait as it gives just a slight amount of softening to smooth the skin without looking like a soft-focus filter was used. Other strengths are available from Calumet up to Soft 5.

Lee also has a 100mm slide-in glass filter of this type called a Soft Focus 2 for their filter holder.

Filters with Regular Elements. Different softening effects can be achieved with filters of the second type, which incorporate a regular pattern into the filter.

Concentric circles or regularly spaced dimples create a soft halo around the highlights with only a hint of softness that can be minimized by stopping down the lens.

In screw-in type filters, the B+W Soft Focus 1 and 2 filters utilize a pattern of concentric circles, as does the Hoya Duto filter. The B+W Soft Image is made up of a regular pattern of dots and is recommended for backlit situations, which further enhance the effect.

OTHER SOFTENING OPTIONS . . .
Breathing on the lens, or smearing petroleum jelly or even oils from the cheek or nose over a UV filter are long-standing, but unfortunately, not very repeatable ways of softening a photo.

Filters with other regular patterns are also available. These also act primarily on the highlights while the midtones and shadows are less affected. Tiffen's Soft/FX series, for example, is available in five strengths. With its exclusive coral-colored 812 warming effect, which keeps neutrals nearly neutral but warms the skin tones, an additional five strengths are available as the Tiffen Warm Soft/FX series.

Depending on the pattern, some effects vary with lens opening and others don't. All of these filters utilize light refraction to keep some of the image sharp throughout the photo while creating a glow around the highlights.

Filters with Overall Texture. While softening filters in the first two types are designed to leave some of the image sharp, those of the third type produce an overall, even reduction in sharpness. Filters in this group look and act much like a lens that has been breathed on. They are available as a screw-in or slide-in type from every manufacturer, and in a range of strengths to provide slight to considerable softening.

Along with softening, these filters also diffuse the image, lowering the contrast in varying degrees. They go by the names "diffusion," "fog," "mist," and sometimes "soft focus." However, some manufacturers even label softeners of the pattern types "diffusers," though they do little to reduce image contrast, so again names can be deceiving.

While the pattern-type softeners lower contrast primarily in high-contrast areas, bleeding highlights into

LENSBABY

One of my favorite soft-focus/special-effects lenses for my digital camera is the Lensbaby 2.0. This lens has a glass doublet mounted on accordion bellows. It gives a sharp sweet spot that can be moved about the image area by bending the accordion bellows. As this is done, the sharp area is surrounded by a graduated blur, glowing highlights, and subtle color distortions. When used properly, it's a beautiful effect—and one that is not readily duplicated in software.

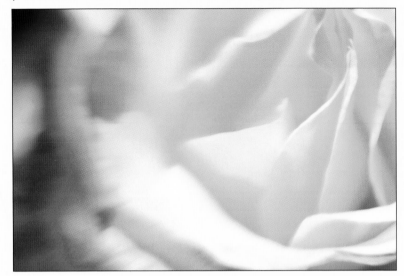

I have yet to find a software equivalent to the Lensbaby. Their unique accordion bellows let you bend and twist the plane of focus for unique effects.

dark areas, overall softeners lower contrast throughout the image. The strongest of these are generally the "fog" filters. They are capable of veiling the entire photo in a white haze simulating real fog. Backlighting, early morning light, and a wide aperture enhance the effect. Overexposing by $\frac{1}{3}$ to $\frac{1}{2}$ stop or combining several of these filters further increases the effect. Using such filters without a lens shade also increases the degree of diffusion. Stopping the lens down will decrease the effect.

Several manufacturers produce fog and mist filters with the diffusion over half or less of a rectangular filter, allowing the transition line to be adjusted to various positions in the frame. They can be used in one position to simulate a rising fog, or reversed for a settling fog. Cokin and Lee both have slide-in filters of this style. A mist filter with clear ends cut by a band of diffusion that can be positioned anywhere in the frame is also available from Lee.

To draw attention to the main subject and minimize distracting elements around it, filters with a clear central area and diffusion surrounding it are available as both screw-ins and slide-ins. Wedding photographers often use one of these when photographing the bride and groom together, or the wedding ring on the bride's hand. Cokin makes three different Softspot slide-in filters with a center circle, two with ovals, and at least twenty more with various colors or effects. Tiffen has two notable filters of this type in their Hollywood/FX line. The Center Spot filter produces a sharp center and soft surroundings without affecting the color; the Warm Center Spot adds their 812 warming filter.

Filters with Net or Random Black Pattern. Overall softening filters are also available that mimic an old Hollywood technique of stretching a nylon over the movie-camera lens. This fourth type of softener contains a net material laminated between acrylic or clear optical glasses. Black netting provides softening with little reduction in contrast. White netting softens and diffuses the image. By incorporating different spacing in the netting, manufacturers produce filters of this type with varying degrees of softening.

Many manufacturers have their own unique sets. Lee Filters' Net Set consists of two black, one white, and one flesh-colored net-type filter. Each has a clear area that is offset in the rectangular filters so that it can be positioned somewhere other than the center of the frame, or out of the frame completely.

Tiffen's Black Pro-Mist line offers a unique pattern of black dots in the filters, giving four degrees of softening without reducing contrast. Widely used in the film industry for softening, they appear to have a black pattern randomly splattered over their surface. There are also three Warm Black Pro-Mist filters. Unlike other softening filters, all of the black net and dot filters require a slight exposure increase.

Degree of Softening. The softening effect of these filters is dependent on several factors beyond just which of the four groups the filter comes from. Lighting is by far the most important, but subject size and even film contrast play a role.

Lighting. With low-contrast lighting, such as portraits taken under an overcast sky or lit in the studio with a broad light source, the transition from lighter to darker areas is already soft. Adding a softening filter further smoothes this transition. With higher-contrast lighting, a stronger softening filter is required to give the same visual softening to the highlight–shadow transition. However, strong backlighting in outdoor portraiture and landscape photography calls for less softening since the subject contrast is usually low, although the scene contrast can be quite high.

Subject Size. The size of the subject in the frame is also important. For a consistent look, a headshot requires more softening than a full-length portrait. This is partially due to the amount of background visible. A white or light background will diffuse into the full-length subject, lowering the contrast and increasing the apparent softness with most diffusion filters. With a sub-

I photographed this bride with a digital back on a medium-format camera. It was too sharp! I used B+W's Warming filter (Portrait and Family Set) to warm the image and the Soft Focus filter in the same set to soften it.

ject filling the frame, little or no background is seen. However, even with a darker background, more softening would be required in the headshot.

Because of factors like these, each style of softening filter is made in different strengths. No one single filter will give consistent results in a variety of real-world situations. It is best to find a style that produces the desired effect and purchase the full set of strengths in that style. This will produce similar results in a variety of lighting situations, or a variety of results in the same lighting situation.

Other Options. Tiffen offers some other unique softening filters. Their Black and Gold Diffusion/FX filters are excellent for tight close-ups. The look is unique and, although it is diffused, it doesn't look like a soft-focus filter. The Black filter produces an image that is diffused with no color change, while the Gold filter warms the image slightly. Tiffen's Glimmerglass, a relatively new addition to their Hollywood F/X diffusion filters, adds softening, reduces contrast, and produces a glow in the highlights.

Counting all of the different types, strengths, warmths, and sizes of softening filters, there are more than a thousand choices available for use over the lens while taking the picture.

SOFTWARE FILTERS

While I think it is fair to say that there are no exact copies of these different camera filters available in software, given the infinite number of slider positions in the software filters that are available, it is also fair to say that there are more softening possibilities available in software than there are in hardware!

Every image-editing program has a set of softening effects built in. Photoshop's are under the Filter>Blur menu, as are those in Photoshop Elements. In Corel Paint Shop Pro they are found in the Adjust>Blur and Adjust>Softness menus. Ulead Photo Impact calls them Blur filters in the Photo menu. In Corel Photo-Paint they are in the Effects>Blur menu.

Most of these built-in filters offer very little control over the amount of softening. But a few do, and there are some interesting effects available if you like them. The Filter>Blur>Surface Blur filter in Photoshop CS2 produces an almost painterly quality while softening the

The original is a scan from a very sharp medium-format transparency. Using PowerRetouche I was able to soften the highlights, partially soften the midtones, and barely soften the shadows to preserve the look of overall sharpness but still soften the skin.

midtones and shadows without changing the sharpness of the highlights, for example. Sliders give you control over the effect.

Some of the third-party softening filters also give beautiful results with few controls. The B+W Soft Focus filter in the B+W Portrait and Family Set has only a sin-

gle slider to vary the amount of soft focus, but it gives beautiful results that are reminiscent of those achieved using a Zeiss Softar filter.

Other software filter sets not only offer a selection of softening filters, they provide a number of different ways to control and vary the effect. Nik Color Efex Pro

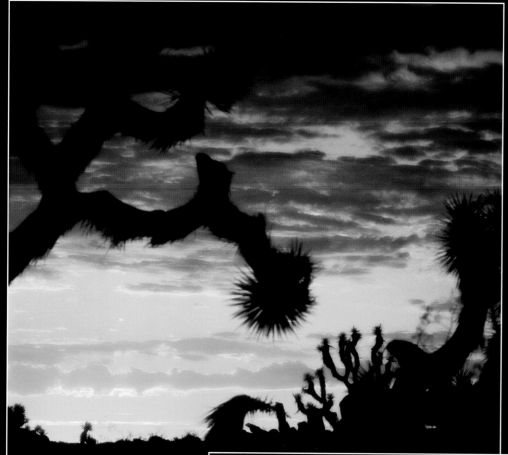

Windows users have some interesting softening filters in the free optikVerve Labs filter set. I find their effects a little too strong for my taste with portrait subjects, but I like using them with landscapes like this sunrise at Joshua Tree National Monument in California. On the left is the Ambiance filter; below is the Halo filter.

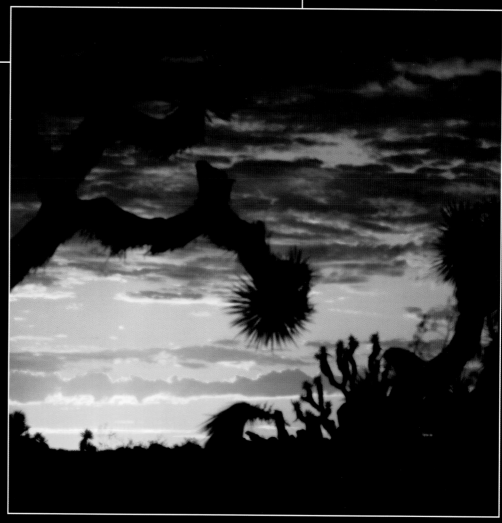

2.0 includes a Classic Soft Focus, and a Fog filter with several sliders in its set of traditional filters. These can be brushed onto any area of the image you choose from the File>Automate>Nik Color Efex Pro 2.0 Selective menu in the latest Photoshop and Photoshop Elements programs. There is also a Center Spot filter with several preset shapes whose sizes, but not their position in the frame, are adjustable.

There is also a Dynamic Skin Softener filter in Nik's traditional set. In its automatic mode it works only on skin-colored areas, softening them while lowering the contrast slightly. It can also be brushed on through the Selective option in the Automate menu (see above) if you are using the latest Photoshop or Photoshop Elements.

The PR Soft-Focus filter in PowerRetouche offers you all the controls that you would want to adjust the softening effect. You can adjust the softness and the spread (halo) over a wide range with the sliders provided, but you can also elect to apply the softening to the highlights, midtones, or shadows with other sliders.

If you're on a Windows computer, the free Virtual Photographer software from optikVerve Labs has two interesting softening filters, Ambiance and Halo.

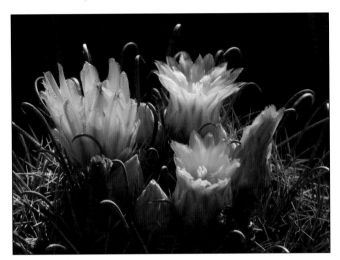

Among the extensive softening filters in Digital Film Tools 55mm collection is the Center Spot. The center of the spot can be positioned anywhere in the original (left) that you want to remain sharp, then there are controls to adjust the size of the spot and the degree of softening to produce the final result (below).

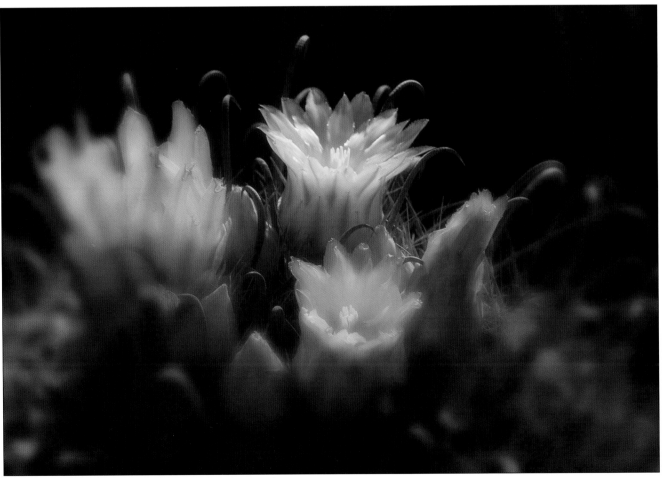

Ambiance brightens and saturates the image, then applies a blur for softness. Halo darkens and increases the contrast, then gives a halo around elements in the photo. With portraits, I found them a little heavy-handed at the default settings, but they worked well with landscape images.

But the clear winner in both sheer numbers of softening filters and the control provided for each filter is Digital Film's 55mm collection. It includes Black Mist, Center Spot, Defocus, Fog, Mist, Warm Mist and Soft Effects filters. And the Fog and Warm Mist filters even allow you to choose the color of the fog or mist!

The 55mm Center Spot filter gives a sharp center with diffusion surrounding it. You can position the center anywhere in the frame, adjust its size and then control the amount of diffusion surrounding the sharp center. This filter from Digital Film gives you much more control than you have with a center spot filter over your lens.

There are even software softening filters available that create effects that cannot be achieved with camera softening filters. One of these bleeds the dark areas of the image into the lighter areas. In the black & white darkroom, this is an effect I used to achieve by using a piece of tan nylons stretched in a large filter adapter ring during part of the exposure. I was never able to satisfactorily duplicate the look in the camera, so it should come as no surprise that I love having the ability to do just that with Nik's Midnight filter (in the stylizing filters set). The Midnight filter, when used alone, bleeds the dark tones into the surrounding areas. The variants of this filter (Midnight Blue, Midnight Green, etc.) also add an overall color at the same time (blue, green, sepia, or violet). You are able to control the effect with a slider, including one to vary the saturation of the color in the variants. I generally increase the Brightness slider quite a bit, so the image looks more like the original and less like it was taken at midnight.

As you can see, software filters, while they may not exactly duplicate hardware filters, offer a variety of softening that exceeds the effects that can be achieved in the camera. Where portrait and wedding photographers may carry two or three softening filters for use when shooting, software gives us an enormous variety at our fingertips.

Nik's Midnight filter bleeds the dark values of the image into the highlights. This cannot be done with a camera filter, but it is similar to the result achieved in the darkroom by exposing through a tan- or black-nylon diffuser held between the enlarger and the paper.

6.
NEUTRAL-DENSITY AND CONTRAST-CONTROL FILTERS

Digital cameras give us far greater control over exposure and contrast than we have ever had with film cameras. With ISO settings from 50 to 3200 available at the press of a button, lens apertures from f/2.8 to f/22, and shutter speeds from 30 seconds to $\frac{1}{8000}$, it's hard to imagine that there would arise a situation where we couldn't find a combination of these settings to match whatever creative requirement we might have. But these situations do arise—and when they do, neutral-density filters, whose sole purpose is to reduce exposure without affecting color balance or contrast, can be the solution.

Similarly, digital cameras give us menu options for contrast control. Nikon calls these controls "tone compensation" and offers five options in the camera. Other manufacturers offer similar settings with different names. I always leave my digital cameras set on the "less contrast" setting, then adjust the contrast during the RAW conversion or when I am adjusting the image in Photoshop. However, there are times when you look at a scene and just know that it is too contrasty, even with this setting. There are both hardware and software filters available to help when that happens.

NEUTRAL-DENSITY FILTERS
Camera Filters. *Types.* Neutral-density (ND) filters are available in three varieties: evenly coated; center weighted (with the center coated and the outer edge clear); and graduated, which we looked at in chapter 4. The table below shows the common neutral-density filters, along with their filter factors and the exposure increase necessary for each.

KODAK WRATTEN NEUTRAL DENSITY FILTER NO. 96

NEUTRAL DENSITY	FILTER FACTOR	INCREASE IN EXPOSURE (STOPS)
0.1	1.2	$\frac{1}{3}$
0.2	1.5	$\frac{2}{3}$
0.3	2	1
0.4	2.5	$1\frac{1}{3}$
0.5	3	$1\frac{2}{3}$
0.6	4	2
0.7	5	$2\frac{1}{3}$
0.8	6	$2\frac{2}{3}$
0.9	8	3
1.0	10	$3\frac{1}{3}$
2.0	100	$6\frac{2}{3}$
3.0	1,000	10
4.0	10,000	$13\frac{1}{3}$

Evenly coated ND filters are available in densities up to a filter factor of 1,000,000 for specialized scientific applications! B+W offers screw-in ND filters with factors to 10,000. Photographers seldom have need for anything greater than a filter factor of 8, requiring an exposure increase of 3 stops.

If the need arises, these filters can even be used in combination with one another to further decrease the exposure.

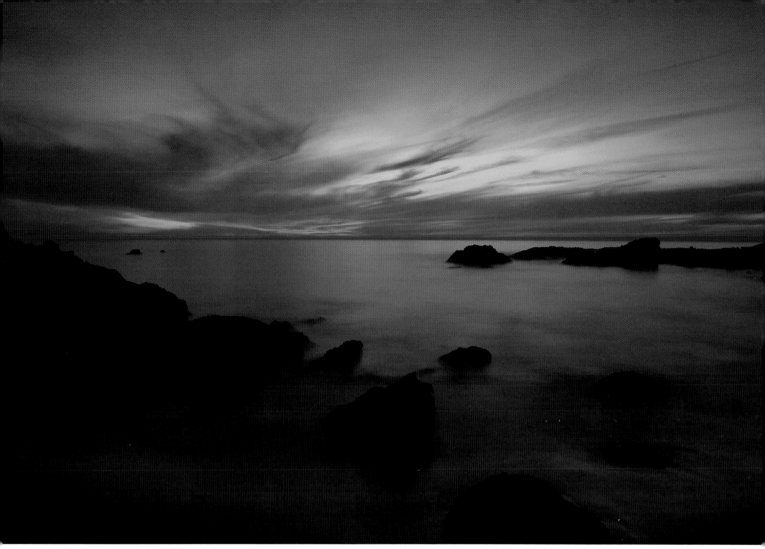

With an exposure of 30 seconds or longer, waves near the ocean shore take on a misty look. I used 6 stops of neutral density and a Cokin Sunset I filter (which also added density) to achieve this 30-second exposure at f/5.6 at ISO 100 on my Nikon D2X.

Both B+W and Singh-Ray offer a continuously variable neutral-density filter, often called a double polarizer. It consists of two sheets of polarizing material in the same filter mount. When the axes of polarization of the two coincide, the filter cuts the light by about 2 stops, as if there were only one polarizing sheet present. As the filter is rotated, the light is slowly cut off until practically no light passes when the two sheets are at an angle of 90 degrees to one another. At maximum, a double polarizer cuts the exposure by about 8 stops. This one filter, although expensive, saves carrying a set of ND filters. Unfortunately, they are only available in a limited number of screw-in sizes.

Center-weighted ND filters are made for specialized applications and matched to specific large-format wide-angle lenses to even the exposure from center to edge. Even though some wide-angle lenses for digital cameras exhibit this same vignetting effect, we can correct it using software tools, and we don't need this type of filter on our lenses.

Using ND Filters. I use evenly coated ND filters most often when water plays a role in the image. To achieve a misty-looking ocean, you'll need a shutter speed of 30 seconds or longer. While the noise-reduction built into the latest generation of digital cameras (and available in software) makes it possible to achieve good results with exposures this long, you may need 6 to 8 stops of neutral density at ISO 100 to achieve this exposure—even at sunset and with the lens stopped down to f/22!

Flowing water in a brook or waterfall doesn't need this long an exposure. A 1- or 2-second exposure will smooth the motion if the water is moving quickly. A 10-second exposure *certainly* will. Both of these often require a ND filter, even with the lens at its smallest aperture.

There are also situations where you want to separate the subject from the background by using the lens wide open but don't want to use a high shutter speed. Or you may want to pan your camera with a moving subject and need to lower the shutter speed in bright light to do it.

In both cases, a neutral-density filter over the lens is the answer.

Software ND Filters. Unfortunately, software solutions won't help in any of the situations above. When it comes to correcting areas of overexposure, however,

With a shutter speed of $^{1}/_{250}$ second at f/8 (left), you lose the sense of the river rushing over the rocks. However, at 4 seconds at f22 (below), you get the feeling that the water is really moving fast. I used $4^{1}/_{3}$ stops of neutral density overall. I also used a Cokin Gray 2 grad on the sky to draw attention to the water.

The slight overexposure on the image to the right was quickly corrected to the exposure seen above with no loss of image quality using PowerRetouche.

software ND filters can be useful. Two companies, PixelGenius and PowerRetouche, make software ND filters that photographers can relate to.

If you are shooting JPEGs and need to correct over- or underexposure in your image-processing software, you have a variety of tools. However, they are all calibrated in a seemingly arbitrary numbering system that often isn't directly related to terms we understand, like

EV or f-stops. Even the exposure-adjustment scales in some RAW file conversion software use seemingly arbitrary values. Adobe Camera RAW, for example, allows you to adjust exposure from –4.00 to +4.00 in hundredths of an increment. It took a little searching to find out that these are indeed related to f-stops.

PixelGenius, on the other hand, in both the Photo-Kit and PhotoKit Color filter sets, allows you to adjust

In scenes with high contrast, like the one on the left, it is important not to overexpose the highlights when shooting with a digital SLR. This can lead to underexposed midtones and shadows. Using the Tiffen Ultra Contrast filter while shooting reduces scene contrast, as it has in the image above, without causing flare or other image problems.

exposure in ±¼-, ½-, ¾-, and 1-stop steps. In PhotoKit, the filters are found in the Tone Correction menu; in PhotoKit Color, they are in the Tone Enhance menu. Because all PixelGenius filters are applied to a new layer, you can employ a layer mask to paint away the effect of the digital ND filter in regions that you don't want adjusted.

In PowerRetouche you have even more control—you can adjust the exposure ±5 stops. You can also apply the adjustment to the entire image; individually to the

shadows, midrange, or highlights only; or in varying degrees to any combination of them. If you choose, the software will also show information lost in the shadows and highlights by coloring them.

Both the PixelGenius and PowerRetouche filters will also work on RAW files, making these powerful tools to solve any exposure problems you may have. But they solve a different set of situations than those solved by neutral-density filters used on the camera.

CONTRAST-CONTROL FILTERS

Camera Contrast-Control Filters. Even with the controls available in your digital camera it may not be possible to reduce the contrast enough. As mentioned previously, it is important to meter and capture scenes without overexposing the highlights. That means shadow detail will be lost in high-contrast scenes. We encounter scenes of this type quite often. Strong back-

lighting is one example. Shooting in deep shade with brightly lit areas surrounding or shooting in the midday sun are others.

Trying to open up shadows in postproduction will work, and there are some software filters to aid this, as we shall see. But opening shadows in postproduction usually means making noise visible in those areas as well. It's better to hold as much information in the original capture as possible for the highest-quality image.

Tiffen, in its Hollywood/FX line, has my favorite contrast-reducing filter: the Ultra Contrast. This filter won a Technical Achievement Award from the Academy of Motion Picture Arts & Sciences and is widely used in the film industry. It lowers contrast and captures detail lost both in the highlights and in the shadows without introducing any flare or degrading the image in any way.

Software Contrast-Control Filters. Digital Film Tools includes an Ultra Contrast filter in its 55mm

The UltraContrast tool in the 55mm collection from Digital Film Tools is the best contrast-control plug-in I have found. It allows you to work separately with the shadows and highlights and see what you have changed before you apply the filter. The range of control is exceptional. I used it here to reduce the contrast in the original image that I had shot to demonstrate the use of the Tiffen Ultra Contrast filter.

plug-in collection. It works in a very similar fashion to the hardware filter, lowering brightness in the highlights and increasing brightness in the shadows, but with much more control.

It works in a very similar fashion
to the hardware filter,
but with much more control.

The filter has sliders to adjust the amount of brightness change for each end of the brightness range. It also features Position sliders to select the highlight and shadow values to be adjusted, and Range sliders to control the range of values to be adjusted. Higher Range settings select a wider range of highlight or shadow values to be adjusted.

Once you make rough adjustments with the Highlights and Shadows amount sliders, you switch to black & white images of the original by selecting the Highlight or Shadow option in the View drop-down box. These views are like masks, showing you a range of tones, with white indicating areas that are fully affected by the adjustment, gray indicating partially affected areas, and black indicating areas that are not affected at all. You use the Position and Range sliders on these monochrome images to select what areas will be adjusted. In the View menu you can also toggle between the original image and the output image to see the full effect of the adjustments.

Separately, the hardware and software UltraContrast filters can only do so much to lower contrast. Using both of them together will do even more. Every image-processing program provides tools to adjust contrast, whether through Curves or other means, and these are available to you also. But I find the UltraContrast filter from Digital Film tools to be the easiest and most visual means to control contrast in postproduction.

Sometimes, only a minor adjustment is needed to an image to lower the contrast, as in the image above. Those images can often be adjusted with adjustments to the Contrast, Levels, or Curves control in your image-processing program. I prefer the Curves tool in Photoshop because of the control it gives me.

ENHANCING FILTERS
FOR LANDSCAPES AND PEOPLE

LANDSCAPES

Camera Filters. If the forest trees, fall foliage, or blue sky in your digital images never seem as intense as you would like them, then enhancing filters are the answer. Also known as intensifying or didymium filters, they are made of glass blended with rare-earth elements that selectively transmit and absorb specific wavelengths of light. The original and still most common type enhances reds, oranges, and yellows. Models are available from a number of manufacturers, including Tiffen (the origina-

tors) and Lee. Recently, other suppliers, Singh-Ray in particular, have introduced intensifying filters for greens and for blues. Enhancing filters are also available in combination with polarizing filters.

Enhancing filters require experience to use effectively. They're certainly not for anyone looking for "accurate" color; they're the "Velvia" of digital imaging. Additionally, their effect can look quite different on the camera's LCD and on the computer monitor than when looking through the lens.

Any warm tones in the scene will be enhanced with the Lee Enhancing filter. These rocks were brown and the effect didn't appear especially dramatic through the lens, but the resulting image showed a very strong enhancing of the rocks and no change to the blue sky.

Unlike color-balancing filters, whose effect is uniform throughout the color spectrum, enhancing filters affect only a specific range of wavelengths, leaving other colors unchanged. The Lee Enhancer, used on the lens, works on the warm end of the spectrum, changing the unfiltered scene (left) to the filtered capture (right).

Don't confuse enhancing filters with the color-balancing filters discussed previously. Where the effect of those filters is uniform across the spectrum, enhancing filters target a narrow band of colors and have only a small effect outside this band. Those that intensify reds the most, for example, tend to to desaturate greens and give a magenta cast to neutrals (particularly noticeable in white clouds); those that give less enhancement have less effect on neutrals or other colors. Using the enhancing filter in combination with a polarizing filter restores some of the saturation lost to the enhancing filter's complementary colors but requires a significant amount of exposure compensation.

The degree of enhancement is also dependent on your camera settings and, to some extent, your camera's sensor itself. Any color can only become so saturated. It is a good idea to shoot in RAW mode with these filters so that you can experiment with the saturation settings in your RAW processing software. It is also fairly easy to create levels of saturation with these filters that cannot be reproduced in a print of the image.

Although these are some of the most expensive camera filters available, their ability to intensify certain colors without forcing an overall change is worth their expense if you like to do your intensifying while you are shooting. Of course, you could save the expense and use software filters, several of which do an excellent job of enhancing specific colors in very similar ways to optical enhancing filters.

Digital Filters. In the 55mm collection from Digital Film Tools is their Enhancing filter. By adjusting the Position and Range sliders it is possible to enhance the

warm or cool colors independently, or enhance all the colors.

OptikVerve Labs' Windows-only Virtual Photographer includes two useful filters for enhancing. The first is aptly named Fall Foliage and does a great job enhancing fall colors, particularly if the photo is taken on a dull, overcast day. A slider lets you adjust the effect. Like the camera filters, software filters show a greater

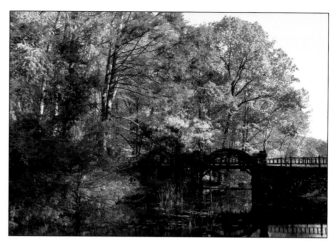

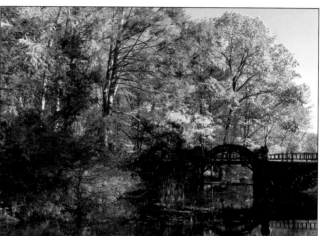

The Enhancing tool (above) in the 55mm collection from Digital Film Tools gives you the ability to enhance the red end of the spectrum, the blue end, or the entire spectrum by choosing appropriate positions of the sliders. Using the 55mm software Enhancing tool on the original image (top right), only the blues were adjusted (right). In the next image, the entire photograph was enhanced (below).

The Fall Foliage filter found in the Windows-only software from optik-Verve Labs really punches up the oranges in the original image (left) to produce the final version (above). Another filter in the set, Sunset, has an even stronger effect but yields more reds.

effect on paler, less saturated colors than on those that are already reaching maximum saturation. And in the case of the Fall Foliage filter, it even gives a slight warming to whites.

The other filter in the Virtual Photographer set is the Sunset filter that produces a stronger effect with more reds than the Fall Foliage filter, which is more orange. The interface encourages you to play around with different combinations since the program stays open, as if it were a stand-alone, allowing you to try different settings and filters without canceling and reopening the program.

In Nik Color Efex Pro 2.0's stylizing filters set, the Enhance Foliage filter is available to make any grass or tree or plant look strong and healthy. Compare the original (right) with the enhanced (below). Photo by Amelia Sholik.

The Indian Summer filter from Nik Software not only enhances reds, it converts other colors to reds and oranges. Compare this filtered version with the original image that appeared earlier in the chapter (page 67).

There are also two enhancing filters in Nik Color Efex Pro 2.0, located in the stylizing filters set. The Enhance Foliage filter is designed to work on greens. Its three presets can add some yellow into the greens, brighten them with a light-green enhancement, or saturate them with a rich dark green. If you want your lawn to look like a well cared for golf course, this filter will do it.

The Indian Summer filter from Nik enhances warm colors and has four different presets: a weak and strong red enhancer, and a weak and strong orange enhancer. None of them seem to affect neutrals or blues, but they do change the color of greens to red or orange. It will definitely turn your green grass brown. Of course, you could always use a mask to control the area the filter affects.

While most people would associate the warm enhancing filters with photos of fall foliage, they are useful in any image where you want to easily boost the warm colors without having much effect on blues and neutrals. This is especially true of the software filters, which give you much more control over the effect than the hardware filter.

Warm enhancing filters would certainly add to the warmth of sunrises and sunsets or to other scenes with predominantly warm tones. They are definitely not for portraits. There are other enhancing filters for people photography.

PORTRAITS

In chapter 2, I mentioned using the 81 series of light-balancing filters to warm flesh tones when shooting por-

traits. The downside to this is that they warm everything in the photo, not just the skin tones. There is really no camera filter that will selectively warm flesh tones without affecting the overall color balance, but there *are* software filters.

Two effects are available in PixelGenius' PhotoKit Color/Color Enhance set. They are called Skin Enhance and Skin Enhance + Mask. Both create a new layer with the effect applied. Skin Enhance lightens the skin and adds a subtle yellow tint. Skin Enhance + Mask does the same, but it also creates a layer mask so you have more control in adjusting the effect.

Skin Enhance works amazingly well in the images I have tested it on, which include a range of ethnicities. It is a quick way to enhance any portrait, but is only available to Photoshop 7 or later users on either Mac and Windows computers. In combination with Nik Software's Dynamic Skin Softener filter, it is probably all you would ever need to quickly refine any portrait.

The Skin Enhance tool in PixelGenius has two flavors: one creates a new layer with the enhancement applied, the other creates a layer set with a layer mask. I used the layer mask option here to give me more control over the original (left). When I was done, I brushed Nik Software's Dynamic Skin Softener onto the highlight side of the face to smooth the skin and produce the final result (right). Model: Tod.

8.
SPECIAL-EFFECTS FILTERS

Here's where we truly separate the traditionalist photographer from the experimentalist, anything-goes-if-I-like-it photographer. While Hollywood has been using special-effects filters since the 1930s, their use (and overuse) in still photography didn't take off until the 1980s, when Cokin introduced them to the market.

Now, thanks to a number of hardware filter manufacturers, we can turn points of light into multi-pointed stars or rainbow patterns, turn subjects into multiple images, or add "speed" streaks to imply motion. Software filter manufacturers have not only found ways to duplicate many of these effects, they have added many of their own. Some simulate darkroom techniques such as solarization and posterization. Others draw on artistic media such as oil paints, watercolors, colored pencil, and pastels. And many others have little correspondence to anything that existed before a software filter designer discovered it could be done.

If you're an experimentalist, open an image and apply the filter.

The end result of using any of these filters, either hardware or software, is an image that looks manipulated, sometimes ridiculously so. But that doesn't mean that some of them shouldn't find their way into your gadget bag or onto your hard drive, to be used occasionally when the appropriate scene will benefit from them.

In this chapter, I will cover some of the hardware and software filters that I use—along with some other software filters that I find interesting. Many of the plug-in sets that you will want to own to have access to a particular filter will also contain some special-effects filters. If you're an experimentalist, open an image and apply the filter. Someday you may find the right image for it. If you're a traditionalist, you may want to move on to the next chapter.

STAR FILTERS
Hardware Star Filters. From simple four-pointed stars to asymmetrical sixteen-pointed patterns, to rotating plates of etched glass capable of a multitude of star effects, these filters are used extensively by still, motion picture, and television camera operators to add sparkle to point-light sources. They are particularly effective in scenes where there are a multitude of small, bright light sources against a dark background, although too many lights can make the effect dominate the scene.

Star filters are commonly used in city scenes or waterfronts at dusk and night, when photographing lights on Christmas trees, or when shooting scenes that are lit with candles. But they also have a place in daylight—with backlit scenes of water, or reflections off sunglasses, cars, or architecture, for example. The sun

makes a very effective point source, particularly when it is partially blocked by a tree or other object.

Star filters are made from glass or resin that has been etched in a fine grid pattern. The depth, spacing, and pattern of the grid determine the resulting star. Most star filters have the pattern evenly distributed over the entire surface, although Lee Filters offers models with the pattern in only a section of the filter so that it can be positioned in the frame to give stars in some areas but not others.

As part of their A- and P-series slide-in lines, Cokin sells the only two-point and sixteen-point resin star filters on the market, along with the more popular four- and eight-point varieties. In these same series, Cokin also offers a combination star/soft-focus filter called the Softstar that creates a soft halo around the light source along with the star.

Tiffen offers a wide variety of screw-in star filters in their regular filter line. These are made from glass set in a rotating mount. Four, six-, and eight-point stars are available in line spacings of 1mm, 2mm, 3mm, or 4mm. Narrower line spacing produces the brightest stars with the sharpest points but with the most flare. Tiffen's most interesting star filters, however, are in their Hollywood/FX line. The North Star filter has four equally spaced strong arms with eight

smaller arms spaced between them. The Hyper Star, Hollywood Star, and Vector Star filters each have unique asymmetrical designs and shapes.

Hoya also makes an interesting star filter, the Variocross. It has two glass plates, etched with parallel lines on each surface, that are set in independent rotating frames. By rotating the frames you can create a variety of star effects.

All star filters cause some flare, resulting in lower image contrast. In many instances that's acceptable,

Star filters are traditionally used with interior lights and candles, but I wanted to do something different with this scene, and a star seemed appropriate. Partially hiding the sun behind the cactus gives a nice asymmetry to the star. Star filters are usually used at a wide aperture to give a softer effect, but I used f/11 here with an eight-point Cokin star filter, and I like the effect.

even *desirable*, since they are often used in high-contrast situations. It also makes star filters useful substitutes for soft-focus filters in portraiture, adding a subtle star to the highlight in the eye. Flare is greatest with those resin filters that produce closely spaced stars of multiple points. The B+W Double Sunny, a 16-point etched-glass star filter, produces noticeably less flare than the sixteen-point Cokin resin, for example. I find that

a four-point star with 2mm line spacing produces the best compromise in flare vs. star strength and point sharpness.

The size and intensity of the light source, as well as the darkness of the surroundings and the lens aperture used, will determine the final result. The brighter and larger the light source, the more pronounced the effect will be. Small apertures diminish the star effect, while medium to wide apertures produce a softer, wider effect. Using a wide aperture also prevents the etched lines on the filter from coming into focus.

Over the years I have accumulated a number of hardware star filters. Each one is a little different from the others. Even though I've used all of them at one time or another, I rarely use one more often than a few times a year. Now, with the software filters that are available, I don't think I'll need to buy any more hardware filters.

Software Star Filters. There are two outstanding, but very different, star filter plug-ins available. One is Andromeda's ScatterLight Lenses and the other is Mystical Lighting from Auto FX.

Cokin's eight-point star filter is round and fits into the same holder slot as the polarizing filter, so it can be freely rotated. It does add some flare to the image, especially in a scene such as this, so I also added a Cokin Sunset filter to make a more abstract image.

It wasn't possible to mount a star filter on the Lensbaby that I used to make the original image, so I had to add the star with software. Here I used the Andromeda 16-Point Halo filter (Filter> Andromeda>ScatterLight> Stars>Bright Stars>16-Point Halo). After selecting the flame where I wanted the star, I used the sliders to preview different sizes and glows before settling on this.

The Mystical Light filter set from Auto FX has an Adjustment Type called Flare. It contains numerous presets and a wide range of controls over each, although none of them really produce a star effect that looks like a hardware star filter. I created this image with the Hot Coal preset centered on the candle flame, added 24 rays, then adjusted their size, spacing, and other parameters.

The star filter module found in Andromeda's Mac and Windows ScatterLight Lenses plug-in is Stars/ Bright Stars. It offers fourteen presets including several four-, six-, and eight-pointed stars and a sixteen-pointed star with a halo center. There are sliders that adjust the strength of the stars, their length, their glow, and the overall brightness. Best of all, it is easy to apply the Andromeda star filter to only one part of the image by making a selection before opening the filter. For example, to add a star to a candle without adding stars to highlights on a glass in the same image, simply select the candle before opening the ScatterLight Lenses filter. Unfortunately, there is no way to rotate the star effect as you can with a hardware filter, and these filters take some time to render the final image. Also, the effects created with these software filters don't look as sharp as they would with a hardware filter.

In the Auto FX Mystical Lighting filter set is an Adjustment Type called Flare that takes a unique approach to starbursts. While not really duplicating the effect of a

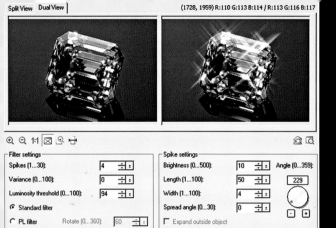

Filter settings

Spikes (1...30):	4
Variance (0...100):	0
Luminosity threshold (0...100):	94

○ Standard filter

○ PL filter Rotate (0...360): 60

Spike settings

Brightness (0...500):	10		Angle (0...359):
Length (1...100):	50		229
Width (1...100):	4		
Spread angle (0...30):	0		

☐ Expand outside object

OK Cancel

LEFT—Windows users have access to the only software star filters that closely resemble their hardware counterparts. Five different star effects are available in Ulead PhotoImpact 10 as part of the Photo Effect Gallery menu. Here is a screen capture of the setting I used to produce the diamond with stars. **BELOW**—This is the resulting image produced with the star filter settings shown in the screen capture from Ulead PhotoImpact 10.

star filter, it allows you to place bursts of light in an image. With nineteen different presets and an array of sliders for each one, it is possible to produce an enormous range of effects.

There is another option, but it isn't a plug-in and it isn't available for Macs. Ulead's PhotoImpact 10 image-enhancement program includes a varied selection of filters. In the Photo Effects Gallery menu are five different star filters. Right-clicking on their thumbnails brings up a dialog box that gives you control over a multitude of attributes, including the number of spikes in the star, how much they vary from one another, their brightness, their width, and their rotation angle. These have the sharpness of hardware star filters, but that can also be controlled. The final effect, and even the preview, is slow to generate, but if you're willing to be patient and you're on Windows, these are the best software stars I have found.

DIFFRACTION FILTERS

Camera Filters. When a piece of clear glass is etched with a pattern of extremely fine microprisms, it will break up the light from point sources or specular reflections into a rainbow of colors. The result will leave no doubt in the viewer's mind that you used a filter on the subject.

Filters of this type, called diffraction filters, are available in many styles. The effect they produce can take the shape of a line, star, circle, or even a square centered on the light source. They are also available with a clear central area so that the subject is unaffected but surrounded by a multicolored array of light. As with star filters, flare can be a problem. However, diffraction filters (even more so than star filters) are most effective with light sources surrounded by very dark areas, and this tends to minimize the effect of contrast-reducing flare.

Diffraction filters are best used at night, where each bright point of light can be rendered as a bright halo of color against a dark background. Like star filters, diffraction filters are also effective with specular highlights on shiny metal, backlit water, and even the sun. During the day, shooting with the sun partially hidden by a tree, or shooting with a wide-angle lens is particularly effective. This minimizes the size of the sun and the diffraction pattern so that it doesn't overwhelm the image.

B+W has seven different diffraction filters in its Spectra line of screw-in filters. They range from the Spectra 2, which gives two diffraction lines from each light source, to the Spectra 72, which surrounds each light with a ring of 72 rainbow rays. The Spectra Quadro surrounds lights with a spectral pattern in a rec-

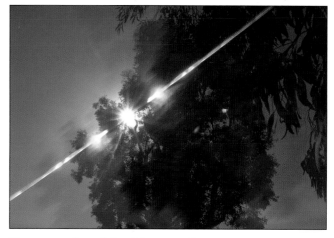

These are a few of the diffraction effects that are possible with hardware diffraction filters. Although the brand I used here is no longer available, B+W has a number of diffraction filters available in its Spectra line of screw-in filters.

tangular shape. Cokin also offers diffraction filters—three in the A- and P-series slide-ins, and a few as screw-ins.

Software Filters. I have yet to find any software plug-in diffraction filters, but Ulead PhotoImpact 10 comes to the rescue for Windows users with five different diffraction filters in its Photo Effects Gallery. As with its star filters mentioned above, there are many controls available if you right-click on the filter thumbnail. The diffraction effect can be linear, circular, or a starburst, and can have two to twenty pairs of streaks

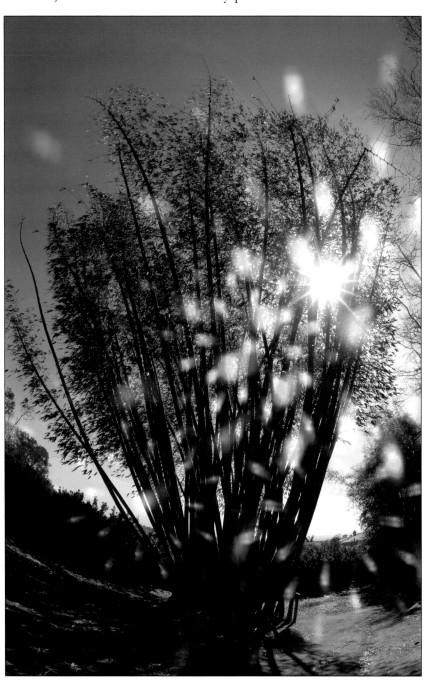

that can be softened, lengthened, strengthened, and rotated. These bear a very good likeness to hardware filters and offer a lot more control.

MULTI-IMAGE FILTERS

Have you ever thought of turning a single flower into a bouquet? With multi-image filters you can.

Types of Camera Filters. One type of multi-image filter has a clear central area that records the subject, surrounded by angled facets that create multiple images. B+W has screw-in filters of this type with five and six images surrounding the central one. Hoya's screw-ins create five or six multiple images. Cokin slide-ins come in the widest variety with five, seven, thirteen, and even twenty-five images surrounding the central one.

Another type of multi-image filter has no central area, just facets that meet in the center. These create identical multiple images without the central image and are available with three facets from B+W and four facets from Hoya. Hoya also makes a Vari-Multivision filter with two independent two-facet glass faces. These can be rotated to create two or four images.

Finally, there are parallel multi-image filters. The B+W 6x Parallel Prism and the Hoya Multivision 6PF screw-in filters consist of a clear glass covering about half of the filter and five parallel facets covering the rest. Cokin's Parallel slide-in filter has a clear area over half of the filter and parallel facets over the rest. The clear areas of these filters transmit a sharp image of the subject and the other five areas produce parallel multiple images

PhotoImpact comes to the rescue if you're looking for software diffraction filters for the Windows platform. Five different varieties are available, and by right-clicking on the filter icon, a variety of controls, like those available for the star filters, are available.

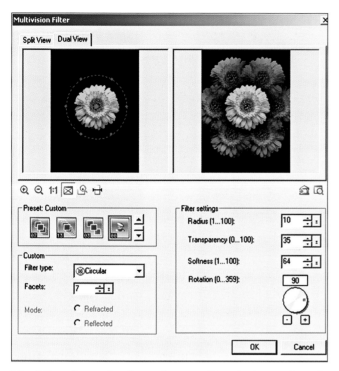

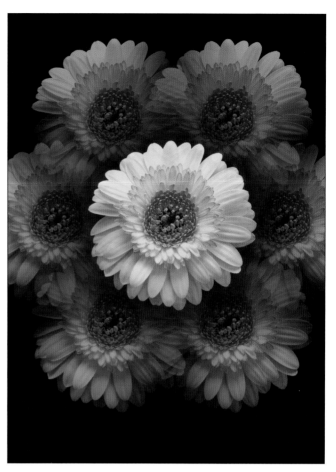

Ulead PhotoImpact has five multi-image filters built into the software. Each has a range of controls like those shown in the screen capture above. To create the multi-image photo to the right, I began with the shot of the central flower. I next extended the black background and eliminated the stem. Finally, I applied the settings seen in the screen capture above.

of a section of the subject. The multiple images appear to flow into the background.

There are other variations, as well. Hoya's Color-Multivision 3F has three faces with no central area. Each face is a different color (red, green, and blue). Hoya's Color-Multivision 5F has five faces: a central one and four surrounding facets. The entire filter is evenly divided into green and orange, producing a pretty wild effect.

Using Camera Filters. The spacing of the effects created by any of these multi-image filters is dependent on the focal length of the lens. They are designed for medium focal lengths, 50–105mm. Shorter focal lengths tend to separate the images too much, while longer focal lengths tend to overlap them too much.

Lens aperture makes a difference also. Too small an aperture makes the edges of each image sharp and makes them too distinct. A smoother blending occurs with apertures of f/4 to f/8. Here is another time when having a depth-of-field preview on your digital camera comes in handy.

Software Filters. I have yet to find any software plug-in equivalent for multi-image filters, but Ulead PhotoImpact 10 has five multi-image options in its Photo Effects Gallery. There are parallel effects, effects with a strong central image and images surrounding it, and effects with the images symmetrically arranged in the frame. As with the other PhotoImpact filters, there are many controls available to create the exact effect you want.

SPEED FILTERS

Sometimes it's fun to create a feeling of action where none exists, or to enhance it when it does. This is the role of speed filters. They add blurry streaks to part of the image while leaving the other part sharp.

Camera Filters. In the past there were several manufacturers producing speed filters, but only Cokin seems to make them now. There are two slide-in speed filters from Cokin, the Speed and the SuperSpeed. The Speed filter has a clear central spot in which to frame the subject. When this is done, parallel streaks radiate out in

both directions. The SuperSpeed filter has nothing on half of it and a thick curved plastic piece on the other half. The final effect shows the actual scene over half of the image and parallel lines streaming from the subject over the other half.

In order to blend the sharp image with the streaks, it's best to use a focal length of 50mm to 100mm and

an aperture of f/4 to f/8. These filters are also most effective with a light, brightly colored subject against a dark background.

The effect is a visual joke, of course, as it is usually obvious the subject is not really moving. You would never see this effect in the real world, but if it appeals to you, play around with it.

Software Filters. It is possible to create speed effects with software filters—in fact, most image enhancement programs have a Motion Blur filter built in. They differ in a couple of ways from the Cokin filter, however. First, the software filter will rarely create speed lines that extend very far from the subject, while the Cokin filters extend the lines from the subject past the

LEFT—No one will believe that the "speed" effect produced by Cokin's SuperSpeed hardware filter is real, but that doesn't mean it isn't fun to play with. **BELOW**—A "spin" on a carnival ride inspired this image, created with Photoshop Elements Radial Blur filter. It only begins to capture the feeling of the ride.

The original image was shot in full sunlight, and the day-for-night effect was entirely created with the DayforNight tool in the 55mm plug-in collection from Digital Film Tools. I added the moon after applying the filter.

edge of the frame. In some cases, this may be fine for the effect you want. Second, the blur created by the software filters is more like the Cokin Speed filter than the SuperSpeed. The "motion" lines extend not only in the direction you want the subject to seem to be coming from, but also in the direction the subject seems to be going. This can be corrected with a layer mask to block the forward direction, and the effect might be just what you want. Like the hardware speed filter, the software filter takes some time and experimentation to master.

DAY FOR NIGHT

Camera Filters. In the early days of Hollywood, cinematographers often needed to create the illusion of cowboys riding across the landscape at night. To do this during daylight, they paired black & white film with filters over their lenses—and it actually looked pretty good.

I used to have fun doing the same thing: shooting black & white film in sunlight with a strong red and strong green filter, then printing it a little dark to create a pretty believable day-for-night effect. However, I was never happy with my attempts to create a day-for-night look with color film. Even with strong blue filters like the 80A there was just too much color in sunlight. It's now possible to do this with a color image, thanks to the DayForNight software filter that is part of the 55mm collection from Digital Film Tools.

Software Filters. The DayForNight filter interface includes an opacity slider that you can use if you want some of the color of the original photograph to come through in the "night" version. There is also a slider that allows you to reduce the blue in the highlights. This is helpful if there are clouds in the scene and you want them to be less blue than the rest of the image. There is a slider to add diffusion, but I always leave this set to zero. I've also tried this conversion with monochrome images, basically tinting them a strong blue,

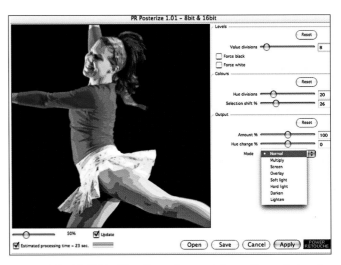

LEFT AND ABOVE—The Posterize tool from PowerRetouche offers a wide range of controls to manipulate the image. I liked this image, but it wasn't perfectly sharp because of the lighting conditions and the dancer's motion, so I decided to posterize it, but with eight levels, enough to keep detail in the face. This screen capture (above) shows the setting I used to produce the final image (left). **BELOW**—even weirder than you thought thanks to Corel Photo-Paint's Psychedelic filter in the Effects>Color Transform menu.

What better subject for Nik Software's Solarization: Color filter than an old transparency of the Grateful Dead's Jerry Garcia? There are five presets available in the filter and an Elapsed Time slider that further varies each preset.

and I really like the look. With monochrome infrared images it is otherworldly.

UNIQUE SOFTWARE FILTERS

We've seen a number of hardware special-effects filters that have few if any software equivalents. The opposite is true also—and to a much greater degree. There are many special-effects filters available in software for which there is no hardware equivalent, but for which there is at least a photographic analog. I'll mention just a few.

Darkroom Effects. Many of the darkroom techniques employed by photographers who liked to experiment with offbeat looks have found their way into software. These include posterization, solarization, and cross processing.

Posterization. Posterization was a technique popularized in the 1960s and widely used in rock music posters and promotional materials. It involves breaking up a continuous tone image into a discrete number of densi-

ty steps. The number of steps can vary, but four is usually the minimum and sixteen the maximum. With more than sixteen steps the image can look continuous tone—and it makes for a lot of work in the darkroom.

PowerRetouche has an excellent Posterize filter that eliminates all those darkroom hours. You can break the image up in two to 128 different steps. With this plug-in, even with 128 steps, the image still looks posterized. As the default, the filter uses the colors of the original image, but there is a Hue slider that allows you to adjust the colors. The effect can be applied to the original image in any of the common blending modes (Normal, Screen, Multiply, etc.) and in any percentage from one to 100. It's a very cool plug-in.

Corel Photo-Paint has a tool in its Effects>Color Transform menu called Psychedelic. It's posterization gone crazy. Adjusting the slider produces a variety of effects, all of them wild.

Solarization. Also popularized in the 1960s with color images, solarization was used by artists decades

Nik Software's Solarization: Black and White filter also offers five presets and an Elapsed Time slider.

room is impossible to say, but the images are believable solarizations.

Cross Processing. In the 1980s, some technician processing film somewhere put a roll of color-negative film in a transparency-processing machine (or vice versa), and cross processing was born. It was the staple of fashion photographers for a few years before a new look came along. Film shooters can still find labs to cross process their film. Digital photographers using Photoshop can use PixelGenius' PhotoKit Color Cross Processing tool, accessed via the File>Automate menu.

With over twenty options, there are plenty of ways to experiment with the Cross Processing tool. Every look is different, and it would probably take as much time to become familiar with the way this filter reacted with your images as it would to actually get predictable results from cross processing film! Unlike some of the cross-processing actions you can find on the Internet, PixelGenius gives you options for E-6 film in C-41 chemistry or C-41 film in E-6 chemistry. While it is difficult, again, to tell if this is how your original would actually look if it were cross processed, there are enough options that you will likely find one that suits your needs.

Artistic Effects. I still have a sheet of rippled shower glass from the 1930s that I used to shoot through, trying to simulate a watercolor look. I haven't used it for years and, with all of the artistic effects available in software, I doubt I'll ever use it again.

Each image-processing program has its own set of artistic filters. While they may be similarly named, they differ in their controls and somewhat in the final look they produce. There are too many to go into here, and they are really beyond the scope of this book. But if you have a particular vision of the way you want your image to look, I encourage you to experiment with these artistic filters—as you should with all of these special-effects filters that you find of interest—and see where they take you.

earlier with black & white photographs. It involved exposing the developing image to a light source, producing a reversal of tones in the shadows and dark lines at the boundary of high-contrast areas. Many image-enhancement programs (including Photoshop, Corel Photo-Paint, and Corel Paint Shop Pro X) have a Solarize filter. Although they produce wild tones, as anyone can by making radical changes in the Curves function, they don't look like true solarization.

The stylizing filter set in Nik Color Efex Pro 2.0 has two filters that get it right, though. One is for black & white images and the other is for color. Both Solarization: Black and White and Solarization: Color provide six different preset looks, with sliders to vary the saturation and amount of the effect. Whether it would be possible to achieve these effects in the dark-

9.
BLACK & WHITE FILTERS

ENDURING APPEAL

With the introduction of photography to the public in the early 19th century, many artists and critics predicted that it would end the art of painting. Yet painting has survived and photography, rather than supplanting painting, caused a revolution in painting. Artists were inspired to create new works that were more an expression of their vision rather than a literal portrayal of the external world.

A similar revolution is going on in photography today. Digital capture is supplanting silver-halide imaging, and there are photographers and critics predicting the end of interest in black & white photography. Their reasoning is based on the ease of capturing and printing a color image. Yet interest in black & white (monochrome) photography and printing actually seems to be *increasing* among digital photographers. I think there are several reasons for this.

Enhanced Control. Probably the most important reason for this renewed interest is the amount of control digital imaging offers. Masking and contrast-control techniques that once required years of darkroom experience to master are now readily available in software. In fact, many photographers, including myself, who are experienced black & white printers have abandoned their wet darkrooms in favor of the computer and inkjet printer and are producing comparable quality work.

Simplicity. The fact that photographers no longer need to set up and maintain a wet darkroom is also

drawing advanced amateurs to digital black & white. Many in this group were always interested in expressing themselves in black & white but didn't have the time or space available in order to become proficient. With digital capture and output, this is no longer an issue.

Better Tools. Finally, camera, printer, and software manufacturers are releasing products that address monochrome digital imaging.

Cameras. At of this writing, several digital SLRs are available with built-in monochrome modes. These include the Nikon D1x, Nikon D2xs, and the Canon EOS 20D.

Techniques that once required years of darkroom experience to master are now readily available in software.

The Canon 20D offers some particularly noteworthy features. Not only does it include a monochrome setting, it also includes built-in digital equivalents of yellow, orange, red, and green filters—plus print toning in sepia, blue, purple, and green. You can even save setups (like a monochrome/orange filter for darkening skies or a monochrome/green filter for lightening foliage) in the camera's Processing Parameters memory bank. If you are capturing photographs in RAW format, these controls can all be applied with Canon's software in postproduction.

Because it's so easy to convert color images to black & white in postproduction, it's usually best to shoot all your images in color. This gives you the most options for using your images.

If you plan on printing directly from a camera that supports black & white capture, shooting a monochrome JPEG is definitely the way to go. However, as you shall see, the greatest amount of control over the image is available with software filters, and these require an RGB color image. So visualize in monochrome, but capture in color.

Printers. Inkjet-printer and ink manufacturers are also releasing products to aid monochrome digital imaging. Epson in particular is delivering inkjet printers designed for high-quality monochrome output.

Other companies are also selling inks and even modification kits for Epson printers to convert them to dedicated monochrome printers. Notable among these are Piezography inks. With these inks, it is possible to create inkjet output with the look and feel of silver halide black & white photographs—and with sufficient print longevity to satisfy all but the most demanding archival requirements.

Software. The final element that is causing an increase in the appeal of monochrome capture and output is the software that has become available. Some software, including that found in imaging programs and from software filter makers, simplifies the conversion of a color image to monochrome. More advanced software even allows you to apply filters to the images to control and adjust the tonal relationships in the image, just as photographers shooting black & white film do.

We'll look at these options below, but first let's look briefly at how filters affect a monochrome image.

FILTERS IN MONOCHROME IMAGES
The primary role of filters in monochrome imaging is to provide separation of gray values where they do not occur in nature. For example, with most unfiltered monochrome captures, a bright red pepper and a dark green pepper, distinctly different when seen in color, will be recorded as very similar values of gray. To adjust

their gray values to make them more representative of how our minds see them, filters are required. Of course, these same filters can also be used to "overcorrect" a scene for dramatic effect.

Color filters transmit light that is the color of the filter and selectively absorb other colors, with the greatest absorption occurring to wavelengths that are complementary to the filter color. (See page 115 of the appendix for more information.) In the final print, tones with the greater exposure will reproduce lighter than tones whose exposure has been decreased. To darken a blue sky, for instance, you would use a filter that is complementary to blue (i.e., a yellow filter). There are a number of yellow filters available of different strengths. These allow you to control how much of the blue will be absorbed.

Yellow filters are not, of course, the only ones that will darken blue. Although yellow is complementary to blue, filters will not only darken their complement, they will darken the components of their complement. Blue and green are components of cyan, whose complementary color is red. So adding a red filter, which would also darken the green in the scene, could also darken the blue sky. Because of the dramatic effect that they have on the final image, red filters are popular in architectural and landscape photography.

Similarly, blue and red are components of magenta, whose complementary color is green. Again, the blue sky could be darkened with a green filter, which would also darken any magenta in the scene. The table below shows the common filters for black & white photography. Some software filters use these same designations.

FILTERS FOR MONOCHROME DIGITAL CAPTURE

WRATTEN FILTER NUMBER	FILTER COLOR	FILTER FACTOR FOR DAYLIGHT*	FILTER FACTOR FOR TUNGSTEN**	POSSIBLE USES
6	Yellow	1.5	1.5	Darkens sky slightly
8	Yellow	2	1.5	Accurate correction of panchromatic film to daylight; darkens sky
11	Yellow-Green	4	3	Darkens sky and lightens foliage; accurate correction of panchromatic film to tungsten light
12	Yellow	2	1.5	Greater darkening of sky and cutting of atmospheric haze
13	Yellow-Green	5	4	Darkens sky and lightens foliage; gives swarthy fles tones to male portraits with tungsten light
15	Deep Yellow	3	2	Dark skies; darkens water in marine scenes
16	Orange	3	3	Dramatically dark skies; greater haze cutting than yellow filters
21	Orange	5	4	Dramatically dark skies; greater haze cutting than yellow filters
23A	Light Red	6	3	Dramatically dark skies; darken water in marine scenes
25	Red	8	6	Extremely dark skies; normal filter for most infrared film
29	Dark Red	16.4	4	Most dramatic filter to darken sky with panchromatic film; used with infrared film
33	Magenta	3	3	Darken foliage, lighten sky
44A	Cyan	6	12	Lighten water in marine scenes, lighten sky, darken sunset. Lighten foliage
47	Dark Blue	6	8	Accentuate fog and haze for mood; lighten water, darken foliage
58	Dark Green	8	8	Dark sky, very light foliage
61	Dark Green	10	10	Dark sky, extremely light foliage
23A+58	Red+Green	run tests		Used in combination with slight underexposure to create day-for-night effects
87	Black	run tests		Infrared transmitting only; used with infrared film
* Approximate values only. Test with your digital camera.				

Color capture.

Monochrome capture with DIX

Monochrome capture with #25 red filter

Monochrome capture with #16 orange filter

If you own one of the cameras that allow monochrome captures you can control the tonal relationship between colors with an appropriate filter. In color, the different hues of the peppers provide separation, but in monochrome, the red and green peppers are very similar in tone. Different filters alter these tonal relationships.

CONTROLLING
TONAL RELATIONSHIPS

Once the relationship between the color of the filter and the colors it lightens and darkens is understood, choosing the correct filter to provide tonal separation in monochrome imaging becomes less of a mystery. In the case of the red and green peppers above, a red filter would lighten the gray value of the red pepper and darken the gray value of the green pepper since red is complementary to cyan, of which green is a component. Similarly, a green filter would lighten the green pepper while darkening the red, since green is complementary to magenta, of which red is a component.

Now the question becomes, which filter to use. The answer lies at the very heart of photography: what is the photographer's reason for making the photograph? If it is to produce an accurate translation of the scene from color to black & white, the correct choice would be a red filter, since the eye perceives the red pepper as lighter than the green.

The choice of filter is usually determined by deciding how the center of interest needs to be lightened or darkened in order to separate it from its surroundings. While this is often thought of as "contrast control," it is inseparable from the "corrective" effect, discussed above, that the filter would have on the scene. Both factors must be taken into account when choosing a filter for black & white photography.

For example, in still-life photography, to use the red and green peppers again, the green filter provides tonal correction, and, if the peppers are sitting in a blue or yellow bowl, also provides contrast between them and their surroundings. If they're sitting in a red or green bowl, contrast control is going to be a problem. The solution would be beyond what could be corrected simply with filters. The ideal solution is to change the bowl

FILTERS ON COLOR CAPTURES

If you don't own a camera that will shoot in monochrome, you can still use these filters on your color captures. The images will be really strongly colored, but this will be eliminated when you convert to monochrome using the Channel Mixer or other methods described later in this chapter. Try it and see.

Shot in color with a contrast-control filter, the original capture will look very weird (top). Once it is converted using Photoshop's Channel Mixer or its equivalent in other programs, though, the results are excellent (above).

to another one that's either blue or yellow, or maybe one of moderately stained blond wood.

PORTRAITURE

In portrait photography, the subject must generally be rendered with correct tonal relationships and must contrast with the surroundings, which includes not only the background but also hair and clothing. Filters have lit-

tle effect on dark-skinned individuals, but a yellow filter (#8) used with lighter-skinned, non-blond-haired subjects, or a yellow-green filter (#11) with lighter-skinned, blond-haired subjects, can be effective when paired with appropriate background and clothing selections.

With male subjects, you can create the rugged, masculine look popularized by the great Hollywood portrait photographers of the 1930s and 1940s by selecting a daylight white balance, then shooting with a yellow-green (#13) or green (#58) filter under incandescent lighting before converting to black & white. Red filters are seldom used in portraiture except for special effects, since they eliminate the separation between skin and lips and emphasize facial blemishes.

LANDSCAPES

In landscape photography, the sky often makes up a predominant element in the composition. Without filtration, however, it will be translated into a much lighter gray value than it appears to the eye. A cloudless sky can be "corrected" with a yellow filter, but a green filter—or, even more dramatically, a red one—will provide contrast control if there are clouds present, darkening the blue sky while having no effect on the white clouds.

If green trees are an element in the landscape, then the green filter will lighten them, providing contrast with the sky, which the green filter darkens. However, in autumn, when the leaves are turning, the red filter would lighten the leaves against a dramatically darker sky.

It is important to move beyond the rigid thinking of "yellow filter brings out clouds" to consider the entire scene, and how filters will change the tonal relationships of all of the important elements in it. The table below lists filters that will darken or lighten the gray-tone reproduction for common hues and their variations. It's worth mentioning that filters will have no effect on a totally overcast gray sky, on white clouds, or on any neutral value for that matter, because all colors are present in equal amounts in neutrals.

SOFTWARE FOR CONVERTING TO MONOCHROME

With this background, let's look first at the ways we can use software to convert a color image to monochrome

CONTROLLING SUBJECT TONAL VALUE

SUBJECT HUE	VARIATIONS OF THE SUBJECT HUE	WRATTEN FILTERS THAT WILL DARKEN GRAY-TONE VALUE	WRATTEN FILTERS THAT WILL LIGHTEN GRAY-TONE VALUE
Yellow	Lemon, Tan, Gold; Light Oak and Pine Wood Finishes	Blue (47)	Yellow (6, 8, 12, 15), Yellow-Green (11, 13), Red (25), Green (58)
Yellow-Green	Chartreuse, Olive	Blue (47), Magenta (33)	Yellow (6, 8, 12, 15), Yellow-Green (11, 13), Green (58)
Green	Lime, Emerald, Kelly, Forest	Blue (47), Magenta (33), Red (25)	Yellow (6, 8, 12, 15), Yellow-Green (11, 13), Green (58), Cyan (44A)
Cyan	Blue-green, Aqua, Turquoise, Sea-green	Red (25)	Green (58), Cyan (44A), Blue (47)
Blue	Sky blue, Powder blue, Royal blue	Red (25), Green (58), Yellow (6, 8, 12, 15), Yellow-Green (11, 13)	Blue (47), Cyan (44A), Magenta (33)
Violet	Lilac, Orchid, Purple, Lavender	Green (58), Yellow-Green (11, 13), Yellow (6, 8, 12, 15)	Blue (47), Magenta (33)
Magenta	Fuscia, Maroon	Green (58), Yellow-Green (11, 13)	Blue (47), Magenta (33), Red (25)
Red	Pink, Rose, Crimson, Scarlet, Brown; Mahogany, Walnut and Cherry Wood Finishes	Green (58), Cyan (44A), Blue (47)	Red (25), Magenta (33), Yellow (6, 8, 12, 15)
Orange	Caucasian Skin, Brown, Beige, Auburn	Green (58), Cyan (44A), Blue (47)	Red (25), Magenta (33), Yellow (6, 8, 12, 15)

and then how we can apply software filters to control tonal relationships.

Channel Mixer. As I mentioned earlier, the best way to create great monochrome images is to capture the originals in RGB, then perform the black & white conversion and apply filters in software. Generally this is an either/or situation as most of the monochrome tone-control software filters perform a grayscale conversion of the RGB image as part of the filter process. But Adobe Photoshop and Corel Paint Shop Pro do provide a tool that I have found to be very useful for controlling tonal relationships and converting to monochrome in one step. This is the Channel Mixer tool found in the Image>Adjustments menu in Photoshop and the Adjust>Color menu in Paint Shop Pro.

Selecting Channel Mixer opens up a dialog box with sliders for the red, green, and blue channels. At the bottom of the dialog box is a box labeled Monochrome.

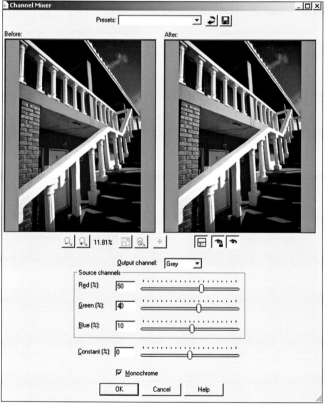

There are many ways to convert a color image to monochrome. Several image-editing programs like Corel Paint Shop Pro, shown here, have a Channel Mixer tool that provides a great deal of control over the conversion. Check the Monochrome box and adjust the RGB sliders to produce an image to your liking. Don't be afraid to use negative values, but the total should normally add up to 100.

A CHANNEL MIXER TIP . . .
When you're playing around with the Channel Mixer, try checking and unchecking the Monochrome box, then adjusting the channel sliders. The base image remains monochrome, but you can add subtle toning effects to the image with the RGB channel sliders.

Click on this to convert the RGB image to monochrome. Then adjust the red, green, and blue sliders to create the monochrome look you want. Usually the best results are obtained when the settings on the three channels total 100 percent, but don't be bound by this (and don't be afraid to use negative values). Just watch that your highlights and shadows don't go off the scale. The Constant slider in the dialog box shifts the value to black as it moves to the left and to white as it moves to the right. With a slight Curves adjustment to the monochrome image, you should be ready to print.

Desaturation vs. Grayscale/Monochrome Conversion. There are other ways to do the grayscale conversion, but what you *don't* want to do is simply desaturate the image. The image will be RGB and monotone but usually pretty ugly and nearly impossible to get to anything worth printing.

Other tools, variously labeled "Grayscale" or "Monochrome," that are built into imaging programs will generally create a better image than zeroing out the saturation of an image, but they offer no control over the conversion. For that, and to apply filters to control tonal relationships, you need to look to plug-in filters.

Filters. As a photographer, I prefer software filters that relate to the hardware filters I have always used—especially when they are part of a package that gives me control over how strongly they are applied. There are several plug-in filters that meet these criteria and do an excellent job, but my personal favorite is Studio Black/White in the PowerRetouche Pro plug-in set for both Mac and Windows operating systems.

Studio Black/White. What sets Studio Black/White apart from other plug-ins is the range of looks and controls built into it. For one, it is the only software where you can choose a film type to begin the conversion process. Seven professional films are available (Kodak Tri-X, T-Max 100, and 400CN; Ilford Pan F+, HP5 Plus, and Delta 100; and Agfa APX 100), and the algorithms used

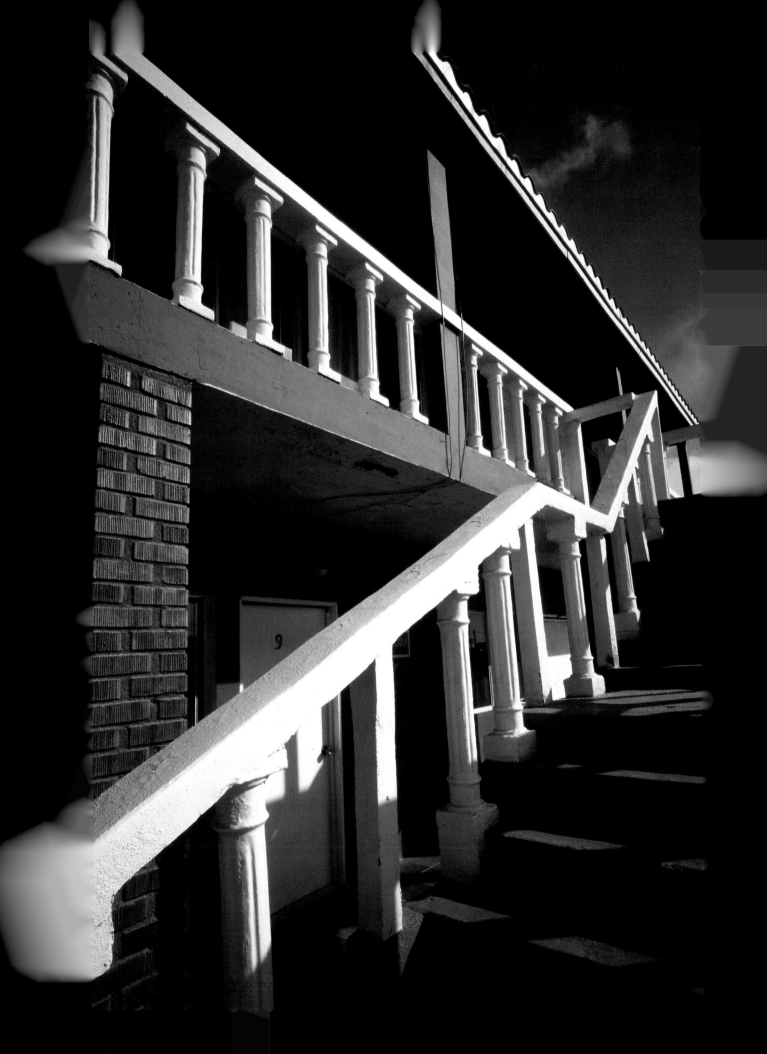

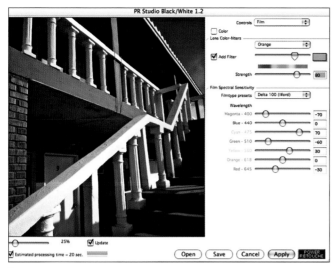

The color-to-monochrome conversion tool in PhotoRetouche software lets you choose the look of a classic black & white film as well as use a tone-control filter during the process. I used the settings in this screen capture (above) to produce the final result (facing page).

One tab in the Convert to B&W Pro plug-in from theimagingfactory gives you the ability to prefilter the image with a color filter, like the orange one shown in this screen capture. The Color Response, Contrast, and Sepia tabs give further options, making this a very versatile tool for color to monochrome conversion.

for the conversion are derived from the spectral response curves of the films. There are also generic panchromatic and orthochromatic looks available, as well as a neutral perceptual luminance conversion.

Additionally, seven tone-control filters (red, green, blue, orange, magenta, yellow, and cyan) can be precisely applied using sliders. There is also a Multigrade Filtering control with a range from 000 to 6 to adjust contrast that graduates of wet darkrooms will relate to immediately.

A number of other controls make this an incredible tool for someone interested in experimenting with black & white, or for photographers who have closed their wet darkrooms but want to use digital tools to create the look they have left behind.

Convert to B&W Pro. Another very capable program is Convert to BW Pro 3.0 from theimagingfactory. Selecting this plug-in from your program's filter menu opens the image up in a new window with another smaller window containing four tabs labeled Prefilter, Color Response, Contrast, and Sepia.

The Prefilter tab allows you to apply a filter of any hue to the image. While there is no relationship between the hues and any hardware Wratten filter number like those mentioned above, the effect of the filter on your image is previewed as you adjust the Hue and Saturation sliders. There is also a densitometer available that will show before and after RGB values anywhere in the image.

If the Prefilter tab doesn't give you enough control, you can use the Color Response tab, which has six sliders at different points in the spectrum, along with a Gamma slider for overall control. This tab is like applying different filters to the image at once, each with different strengths.

The Contrast tab gives you control over the exposure of the negative and the paper as if you were in a wet darkroom. There is a Multi-grade Contrast slider also. Although it isn't marked in grades like that in the PowerRetouche plug-in, you can see the effect of moving the slider in the image preview window.

The final Sepia tab is a little misleading. True, the default setting is sepia toning, but, like the Prefilter, a slider allows you to adjust the overall tone to virtually any hue in the rainbow. Saturation and Brightness sliders give you further control. Again, nothing is labeled to relate to the toning procedures with which you may be familiar, but the preview window does give you a good indication whether you are achieving the toning look you are after.

Virtual Photographer. Speaking of monochrome looks, the free (but Windows-only) optikVerve Labs Virtual Photographer includes more than thirty built-in looks for portrait, landscape, and still-life photographers. These include Classic B/W, Diffuse, High Key, Hollywood, Moonlit, Newspaper, and Paparazzi. There are radio-button presets for applying red, green, or blue filters for each of these effects with a slider to control

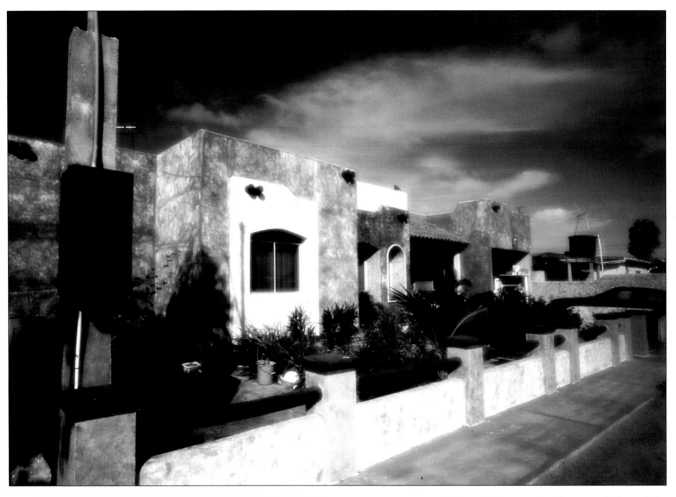

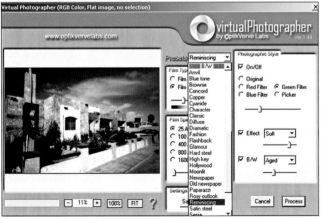

LEFT AND ABOVE—Virtual Photographer from optikVerve Labs (for Windows computers only) holds a wealth of color-to-monochrome conversion tools, as you can see from the screen capture (left). Applying the Reminiscing option with the selections shown resulted in the final image (above). **FACING PAGE**—Photoshop and Photoshop Elements users can do partial conversions to monochrome by brushing on the conversion using Nik Software's B/W Conversion filter from the File>Automate menu. After carefully brushing in areas close to the models, I used the Lasso tool to select large areas and filled the selection in the layer mask (which the filter automatically creates) with white.

the amount. If red, green, or blue don't suit your needs, you can call up a color picker and select any Windows system color for your filter. There is also a wide range of effects that you can apply, such as contrast, blur, negative, or one of several soft-focus filters. Again there is a slider to control the effect. Finally, you can choose a film speed, from 25 to 1600, to add simulated grain. If you envision your image in monochrome, it's almost certain you can create it with Virtual Photographer.

PhotoKit. PixelGenius' PhotoKit has another nice set of photographer-oriented tools for monochrome conversions. Like all of the PixelGenius filters, these are applied through the File>Automate menu. Twelve filters are available (Deep Red, Red, Yellow, Orange, Green, Blue, and ½ values of each). Even though it isn't clear what the exact photographic equivalents of these filters are, they do an excellent job of creating the results I would expect from hardware filters.

55mm Collection. The 55mm filter collection for both Mac and PC from Digital Film Tools also includes

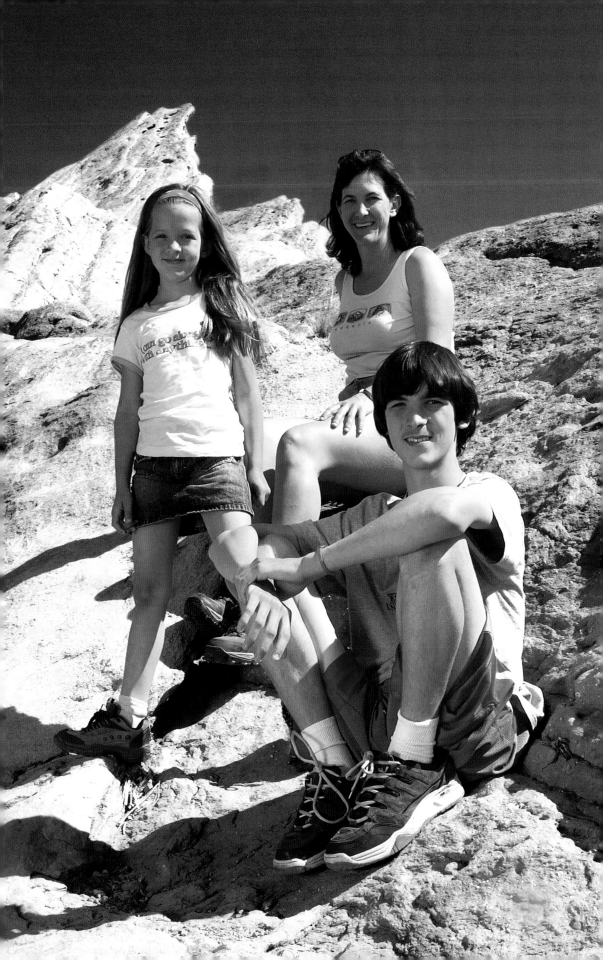

Mystical Tint Tone and Color from Auto FX allows you to work in layers to convert a color image fully or partially to monochrome. Here I used one layer to convert the sky using a red filter for contrast, then added more contrast with the Contrast slider. On a separate layer I lightened the water by using a blue filter. I could have masked the boat each time to preserve its color, but instead I brought the conversion into Photoshop as a layer and did the masking there.

a set of monochrome conversion tools under its Black and White filter heading. Included are red, green, blue, yellow, and orange filters along with Brightness, Contrast, and Gamma sliders. These work well but lack the range of controls in some of the other sets.

Color Efex Pro 2.0. The B/W Conversion filter in the traditional filters set of Nik Color Efex Pro 2.0 takes an approach similar to the 55mm collection. But instead of discrete, preset color filters, there is a color spectrum with a slider below so you can choose any color for your conversion filter. When you apply the Nik filter through the File>Automate menu, you can brush on the black & white conversion, applying it to only the areas of the color image you want it. This is particularly effective

with portrait studies. With other filters, it is also possible to selectively apply the monochrome conversion, but you'll need to make selections or at least create a layer mask. With the Nik filters, you simply choose a brush size and brush on the conversion.

Mystical Tint. The ability to selectively perform a monochrome conversion is extended further in Auto FX's Mystical Tint Tone and Color Black and White filter. Like the other Auto FX filter modules, Black and White runs full screen so you have an excellent view of the results. There are red, orange, yellow, green, and blue filters available, plus a Custom Hue slider.

Although the effects are muted relative to actual hardware filters or those created using other software

packages, the Brightness and Opacity sliders easily correct for this.

In Global mode you can apply a monochrome conversion with a red filter to the entire image, then use the Opacity slider to back it off for a very interesting effect. In the Brush-On mode, not only can you apply the conversion to selected parts of the image with a brush, you can also apply it with Auto FX's Elliptical Fill tool. Also, multiple filters can be applied to the image, so you can easily deepen the sky with the red filter and lighten the water with the blue filter in the same image.

TINTING AND TONING

With all of these options for monochrome conversion, it would be a shame if you could only print them out as black & white, or partial color and black & white. Before we leave this chapter, let's look at some software options that allow you to tint and tone your black & white images for printing.

Printers in wet darkrooms have employed a number of techniques through the history of photography to add permanence to the printed monochrome image. These have included platinum and palladium printing as well as selenium and sepia toning. All of these techniques imparted a unique and distinctive look. Other photographic processes, such as kallitype and cyanotype, also give wet darkroom photos a distinctive monochrome color look. Now all of these looks are available in software filters.

One of the most complete sets is found in Power-Retouche's Toned Photos plug-in. The filters included are Sepia, van Dyck (a form of kallitype), Kallitype, Silver Gelatin, Palladium, Platinum, Cyanotype, Light Cyan, and Silver. Missing, to my surprise, is any filter to replicate selenium toning, which was my favorite in the wet darkroom. The tones in these filters were created from scans of actual prints and I must say that they look right to me. There is plenty of control in the plug-in to

For tinting and toning effects, PowerRetouche has not only the widest selection of presets but also the most realistic-looking results. The screen capture above shows the toning choices and the other available controls. The result of applying these settings results in an image (right) that very closely matches what could have been attained with platinum toning.

adjust the look, and you can apply tone-control filters to adjust the tonal relationships at the same time.

PhotoKit by PixelGenius has my selenium look, as well as three sepia tones, three cold tones, a platinum, and a brown tone. These also look very accurate.

But, while the look is there, neither the labor nor the image permanence is. Wet darkroom purists will likely hate them, but I think they give a unique look and, like any of the filters in this book, with the right subject, they will enhance the appeal of the image.

By selectively masking areas in an image-processing program such as Photoshop or Corel Paint Shop Pro, you can control areas of an image you want to remain in color. Then use the Channel Mixer tool in these programs to convert the rest of the photograph to monochrome.

INFRARED EFFECTS

Like monochrome photography, discussed in the previous chapter, infrared photography is enjoying a resurgence with digital imaging—and for the same reasons: the availability of specialized hardware and the ease of using software plug-ins to simulate the effect.

DIGITAL INFRARED CAMERAS

It turns out that digital sensors are ideally suited to infrared imaging. Where silver halide film is most sensitive to the blue and ultraviolet end of the spectrum, the exact opposite is true with CCD and CMOS sensors. Their greatest sensitivity is in the red and infrared (IR) end of the spectrum. In fact, to limit the amount of infrared radiation that strikes the digital sensor, an IR-blocking filter is mounted over it. There are a few options for getting around this, each with its own costs and benefits.

Remove the Built-in Filter Yourself. To restore IR sensitivity and create infrared digital photos, enterprising photographers have found ways to remove these filters from certain consumer cameras and digital SLRs. There is information on the web for anyone wanting to attempt it on his or her own. Keep in mind, however, that once the conversion is made, the camera will *only* be useful for shooting infrared images.

If you modify your own camera by removing the IR-blocking filter, you will still need an IR transmitting filter over the lens. Unfortunately, this filter is opaque,

meaning no visible light will enter the camera. With a consumer camera this isn't so bad; there is usually a viewfinder you can use for framing, or you can use the LCD on the camera back. If you have modified a digital SLR, however, you won't be able to compose the image with the filter over the lens, so you must tripod-mount the system, compose, attach the filter, and shoot.

With this filter in place, the exposure meter may or may not work correctly, but the histogram will read the image information correctly and it can be used to evaluate the exposure. You will also experience a few stops of light loss due to the IR-transmitting filter.

It turns out that
digital sensors are ideally suited
to infrared imaging.

Have the Filter Professionally Removed. For those inclined to having someone else do the heavy work, a small cottage industry has grown up to modify certain cameras. This involves removing the built-in IR filter and replacing it with an IR-transmitting filter. The cost is approximately $350–500. Commonly modified digital SLRs include the Nikon D100 and D1, as well as the Canon EOS-1Ds, 1D Mark II, 20D, 1Ds Mark II, Digital Rebel, D30, and D60. A professionally modified digital SLR camera can only be used for IR photography, but, since the IR-transmitting filter is mounted on

I made this infrared portrait using a Wratten #87 filter over the lens on my D1X. First I focused with the camera mounted on a tripod, then slid in the filter and made the capture. I shot a range of exposures, but this turned out to be the best. The final exposure was 1 second at f5.6 at ISO 800. Since I was close to the couple and the aperture was fairly wide, I also shot a couple of different focus positions because the lens didn't have an infrared focus-correction mark.

the sensor rather than the lens, it is still possible to compose and focus while looking through the camera. With this modification there is only a few stops of light loss, so the camera can often be handheld and used for moving subjects.

With this method unlike the two others, you will generally not need to adjust the focus for the infrared light. Longer wavelength infrared comes to focus at a different point than visible light. It is usually necessary to focus first with visible light, then manually adjust the focus to the infrared focusing dot on the lens before taking the picture. Stopping the lens down to f/8 or f/11 will also adjust for the focus shift. In cameras that

have been professionally modified to shoot only infrared images, the autofocus mechanism is usually recalibrated so that it will focus the infrared light properly on the sensor.

Use an Opaque Filter. The simplest option is to use your digital SLR with its internal IR filter in place, and simply add an IR-transmitting filter over the lens to block most or all of the visible light. As long as some IR is passed to the sensor, this method works—but at the expense of exposure. It is the method I employ for occasional IR photos.

With this method, I mount the unmodified D1x camera on a tripod and use a #87 filter over the lens. You can also use a #29 filter, which absorbs much of the visible light and creates a slight IR effect. The effects will not be as dramatic as those achieved when using the #87 and #87C filters, which are totally opaque to visible light and therefore transmit only infrared and longer wavelengths.

In-camera meters will give incorrect readings with these filters since the meter's infrared sensitivity differs from the sensor's. With a #87 Lee gel filter and my D1x, the exposure increase is on the order of 10 to 12 stops! This translates into an exposure in the range of one to two seconds at f/8 in bright sunlight at an ISO equivalent of 800. Experience and the LCD screen on the back of your camera are the best guides for achieving the correct exposure.

Since it is impossible to focus through the lens, this method doesn't lend itself to quick grab shots. How-

ever, I have used it successfully when shooting people, even close up, after correcting for the infrared focus shift. For landscapes, where the IR look is used most often, tripod-mounting is standard procedure anyway.

The D1x captures images in black & white, but only in the JPEG file format. I generally do a few tests in JPEG to preview the IR effect and adjust the exposure, making sure the highlights are not overexposed. Then I switch to the RAW file format and capture the image in RGB. After I bring it into the computer, I make further adjustments as needed and do a final conversion to grayscale.

The ISO equivalent of 800 adds some noise that simulates the grainy look of infrared film, but what it doesn't give you is the chunky grain structure and glowing highlights of film-based IR photography. Depending on your point of view, this is an advantage or a disadvantage. If you want more of an IR film look, you can add both simulated grain (noise) and glowing

highlights in postproduction. You can also use software plug-ins for a pseudo-IR film look.

SOFTWARE INFRARED EFFECTS

Several software companies include an infrared filter in their filter sets, so I was really hoping for some easy, inexpensive solution to creating infrared black & white images. Unfortunately, I was generally disappointed in what I found. Blue skies seldom end up as black as they should, reds end up gray rather than a textured white, green leaves sometimes end up dark rather than light, and skin tones can end up all over the gray scale rather than at either end of the scale as they do with infrared film. As for the glowing highlights, they just seem impossible to duplicate.

I think the reason for my disappointment lies not in the lack of skill of the software writers but in the fact that what they are doing is creating something from nothing. Unless you are capturing an actual IR image

Shooting infrared landscapes is much easier than shooting infrared portraits. Here, I mounted the D1X on a tripod in a forest path, composed and focused, added the filter, and shot. The exposure was 1 second at f/8 at ISO 800. I made Levels and Curves adjustments in postproduction.

ABOVE—The Windows-only IR Film plug-in from Chroma Software does a straightforward conversion that emphasizes the red tulips in this scanned image, but without the strong tonal changes and glowing effect you would achieve with infrared film or in an infrared digital capture. The Softness slider adds softness overall, not just primarily to the highlights. **FACING PAGE, TOP**—Nik Software's Infrared: Black and White filter has four options for converting to monochrome infrared. This image of plumeria blossoms against a blue sky was made with the second setting. **FACING PAGE, BOTTOM**—Adding a glow to the highlights in Photoshop as described in the text and adding some noise produced this result from the image converted using the infrared filter from Nik Software.

by one of the methods discussed above, there really is no infrared information in the image at all. Any attempt to create an infrared image from an RGB image involves creating information that isn't there.

Despite these challenges, I have put together a combination of filters and Photoshop tricks that give me results I like. I will share this with you as a starting point for your own experimentation. First, though, let's look at some of the options.

IR Film. If you're on a Windows computer, the inexpensive IR Film plug-in from Chroma Software will give you a pretty good start on creating a pseudo-IR image. There is an IR Bias slider to control the amount

of the infrared effect and I make my adjustments with it. I usually make only a small adjustment with the Softness slider and the Contrast slider before I apply the filter.

Once the photo is back in my imaging program I'll use the Andromeda ScatterLight Portrait halo or Landscape halo filters to soften the highlights (or the method I describe below), adjust the contrast with a Curve correction, add noise if I feel like it to simulate grain and it's done.

Infrared Black and White. If you're on a Mac, or if you want more control over the process on a Windows machine, the Infrared: Black and White filter in Nik Color Efex Pro's traditional set is the one I recommend

I converted an RGB color capture to pseudo-infrared using the Windows-only Chroma software IR film plug-in, then added a glow to the highlights using the technique descrived below under Final Touches. Model: Sarah.

and use most often. Built into it are four preset conversions. Method 1 or 2 (selected from the B/W Infrared Method menu in the diaog box) work best for me with portraits, while methods 3 and 4 darken the sky best for landscapes.

Once you choose a preset, there are sliders to adjust the amount of highlight lightening, overall brightness, and contrast. Unfortunately, the preview image is fairly small so you may need to try it several times before you have the final image to your liking. Be sure to check the image at 1:1, as this conversion can easily add unwanted artifacts. When there is a smooth gradation in the background of the photo, I have had problems with this filter breaking the tones into distinct steps.

Final Touches. The Nik Software filter doesn't have a softening or glow control. You can achieve this with the Andromeda filter mentioned above, or with the following method, which will add a glow only to your highlights. You can use your favorite image-processing program, but here is how I do it in Photoshop.

Select the highlights by pressing the Ctrl/Cmd + Alt/Opt + ~. Save this selection to a new layer by pressing Ctrl/Cmd + J. Apply the Gaussian Blur filter to this new layer with a setting anywhere from a 10 to 50 pixel radius—or even more, depending on the image and the look you're after. Set the blend mode of the blur layer to Normal (the default), Screen, or Lighten. Then, use the Opacity slider to adjust the amount of blur applied to the IR layer.

To add grain, go to Filter>Noise>Add Noise and enter a number to your liking. Be sure to check the Monochrome box.

Save the layered file. Then, if you like, convert the file to grayscale and save the file. You're done!

There's no easy route to a monochrome IR, whether you create it in camera or with software. Both take some thought and planning and a willingness to experiment. But the final result will be an image uniquely your own, expressing your interpretation of the world.

COLOR INFRARED

Before we leave the infrared world, a brief word about color infrared. Although it is no longer available, Kodak produced an E-6 process color infrared slide film for a

few years in the 1990s. It required the use of a strongly colored black & white tone-control filter on the lens; an Orange #15 filter in daylight produced an acceptable flesh tone, for example.

If you bemoan the passing of that film, Nik Color Efex Pro 2.0 offers an Infrared: Color filter (in the traditional set) that produces similar weird color effects. There are five presets from which to choose, along with sliders for highlight lightening, overall brightness, and contrast adjustments. The second preset looks to me a lot like the #15 filter with film rendition; at least it gives an acceptable flesh tone. The other presets give vastly different effects, like using different tone-control filters might give with the color infrared film.

If you have the impression that infrared photography is all about experimenting, you're right. No one has ever seen the world in color or monochrome infrared, so there is no "correct" way to render a scene. With enough interest and experimentation, however, you will begin to see scenes that you feel are best interpreted using the techniques described here. This is what artistic vision and expression is all about.

There is no way to know if color infrared film would have reproduced this white lotus blossom with pink tips and a yellow center in this way, but one of the five presets in Nik Software's Infrared: Color filter produced this result.

11.
CLOSE-UP FILTERS

It had to happen at some point: a filter family for use on the camera that has absolutely no equivalent in software. Welcome to the world of close-up filters—or more rightly, close-up lenses, since they are not really filters. A close-up lens does nothing to the spectrum of the light passing through it. Rather, it extends the close-focusing distance of the lens to which it is attached. Close-up lenses are widely available in both screw-in and slide-in types to attach to the front of nearly any lens. They come in a range of strengths, from 0 to 10 (the higher the number, the greater the magnification).

HOW THEY WORK

Close-up lenses increase the focal length of the lens without requiring any increase in exposure. The strength of these lenses is measured in diopters. A "diopter" is the reciprocal of the focal length of the close-up lens in meters (1/focal length). Thus a +1 diopter lens has a focal length of 1 meter or 1000mm, a +2 diopter lens the focal length of $(1/2)(1 \text{ meter})=0.5$ meter or 500mm, etc.

A diopter acts like a magnifying glass when placed in front of a camera lens that is focused at its infinity setting. The lens-to-subject distance of closest focus is equal to the focal length of the diopter. A +1 diopter lens fitted to any lens focused at infinity will be able to focus on an object 1000mm or about 39.5 inches away. Any object farther than that cannot be brought into focus, but objects nearer can be brought into focus up to a minimum distance determined by the lens.

The focal length of the camera lens determines the field size (magnification) when the supplementary lens is attached. For example, a 100mm lens fitted with a +1 diopter close-up lens and a 50mm lens fitted with a +1 diopter close-up lens will both be able to focus on an object 39.5 inches away. However, the object will be twice as large with the 100mm lens.

USE A TRIPOD
With minimal depth of field, and the possibility of camera shake at high magnifications, I recommend mounting your camera on a sturdy tripod for close-up photography. It's worth the effort to bring home that dramatic close-up shot.

If your digital camera has a smaller than full-frame sensor, then the image size will be as if you had a longer lens attached, but the depth of field will be that of the actual marked focal length of the lens. Actually, this is a great bonus to those of us who shoot a lot of close-up and macro images—more depth of field at a higher magnification!

FACING PAGE—Digital capture has made more people aware of the possibilities of close-up photography. Digital cameras with smaller than full-frame 35mm sensors introduce a crop that automatically enlarges the image and the latest crop of zoom lenses, like the 28–105mm Nikkor used here, have a macro setting to make close-up photography more accessible than ever.

You can use close-up lenses to extend the close-focusing distance of any lens. In this example I mounted them on the Nikkor 105mm f2.5 lens that I often use for portraits. The first photo (top left) shows the maximum image size when the lens is focused at its minimum focusing distance. The others were taken with a close-up lens: Nikon No. 0 (0.7 diopter) (top right), Nikon No. 1 (1.5 diopters) (bottom left), and Nikon No. 2 (3.0 diopters) (bottom right).

IMAGE QUALITY

In theory, close-up filters placed very close to the elements of the camera lens will yield image quality equal to the quality possible from the camera lens alone. This being the case, the higher the quality of the camera lens, the better the results after attaching the close-up lens. In practice, even the highest-quality diopters introduce some aberrations that can affect the quality of the images. Those aberrations increase with the focal length, the aperture of the lens, and the strength of the diopter. Stopping the camera lens down to an aperture of f11 or f16 reduces some of those aberrations, but that doesn't necessarily eliminate them.

Close-up lenses themselves vary widely, so considerable care should be taken to buy both quality lenses and quality close-up filters. Some manufacturers sell multi-element close-up lenses. They carry higher price tags, but the additional element allows for better correction of factors that can degrade the image.

Image quality is highest if the close-up lens is used with a prime (single focal length) lens, not a zoom. And if you take a lot of close-up photos, particularly at larger than 1:1, a macro lens, extension tubes, and even a bellows will improve your image quality immensely.

There are a number of things that should be kept in mind when selecting close-up filters. One is that the numeric designation that manufactures put on them is not necessarily the diopter value. With Nikon, a No. 0 close-up adapter is a +0.7 diopter, a No. 1 is +1.5, and a No. 2 is +3.0.

It is possible to use close-up lenses in combination, but there is a further degradation of image quality.

SUPPLEMENTARY CLOSE-UP LENSES

CLOSE-UP LENS DIOPTER STRENGTH	LENS-TO-SUBJECT DISTANCE (IN INCHES)*	APPROXIMATE FIELD SIZE (IN INCHES)**	MAGNIFICATION	APPROXIMATE DEPTH OF FIELD AT F8 (IN INCHES)
+1	39.5	18x27	0.05x	9
+2	19.5	9x13.5	0.1x	2.5
+3	13	6x9	0.15x	1
+4	10.875	4.5x6.75	0.2x	0.5
+5	7875	3.625x5.375	0.25x	0.375
+6	6.5	3x4.5	0.3x	0.25

* Lens-to-subject distance applies to any focal length lens.
** Field size and reproduction ratio apply to 50mm lens focused at infinity.

Again, stopping down the lens can minimize that degradation. When used in combination, the higher-power lens should be closest to the camera lens. A +1 diopter in combination with a +2 diopter will yield the equivalent close-focusing capability of a +3 diopter, but the image quality is better if a +3 diopter were used alone. Two high-quality supplementary filters of low to medium power used in combination will yield very good results. If necessary, three adapters can be used together, but it's not recommended. The potential loss of quality is too great.

Depth of field with supplementary filters is minimal. When attached to a 50mm lens set at f8 and focused on infinity, the depth of field varies from approximately 9 inches with a +1 diopter to 1 inch with a +3 diopter. At closer focusing ranges and with longer focal-length lenses, the depth of field is even less. The table above shows the minimum focusing distance for common supplementary close-up lenses and combinations of them for prime lenses to which they are attached. Also shown are the approximate field size, magnification, and approximate depth of field at f8 with a 50mm lens focused at infinity. Keep in mind that, if you have a digital camera with a sensor that is smaller than a 35mm frame, the focal length is magnified, but the depth of field is still that of a 50mm lens.

CONCLUSION

Digital technology is revolutionizing photography, impacting the way many of us take, process, and print our pictures. Digital cameras, image-editing programs, and desktop printers have made photography more accessible and more exciting for millions of people. But these technological changes are just tools that advanced amateurs and professionals can access to realize their creative vision. And filters, both those used while shooting and those used in post-processing, are available to us for this same purpose.

The joy of using filters is the endless possibilities they present.

As with all advanced tools, it takes time to master their use, so don't become discouraged if your initial photographs or digital enhancements don't meet expectations. Often, these miscues are part of the learning process that can lead a photographer toward new directions. While it takes a lot of the spontaneity out of shooting, keeping notes of filters and exposures used, at least initially, will speed the learning process and make it possible to re-create pleasing effects in the future. Once the technical aspects of a filter have been mastered, though, don't let arbitrary rules restrict your creativity.

Similarly, plug-in filters can seem overwhelming at first with the myriad of choices each one offers—and also frustrating when you try to repeat an effect that you had produced in the past. Again, keeping notes of the filters you apply and saving the settings will speed the learning process. These notes are simply starting points for further experimentation, however, not recipes to be applied to every portrait or landscape you shoot. The joy of using filters is the endless possibilities they present.

I hope that this book has shown you some of the possible ways you can creatively use filters to correct and enhance your photography and enable you to achieve your creative vision.

APPENDIX

UNDERSTANDING LIGHT

Photography is, by its nature, part art and part science. This is one of the many dualities in photography. Technological advances in digital cameras have made it easier to take photographs by masking many of the complexities of the technology. With today's sophisticated cameras, just about anybody can take a technically correct photograph. Still, a basic understanding of light and how it relates to the final image recorded on film is essential in order to understand how filters work.

Obviously, the characteristics of the light falling on a subject is one of the primary factors in determining how a subject will be recorded. These characteristics include: the size of the light, which could be anything from a small spotlight to a diffuse overcast sky; the direction of the light, which could be from the side, directly overhead, or from the back; and the color temperature of the light, such as "warm" (reddish, sunset light) or "cool"(bluish, predawn light).

Portrait and commercial photographers working in a photo studio are fortunate to have complete control over each of these characteristics. Outside of the studio, the ability of the photographer to control these characteristics is far more limited. In both cases, however, understanding these characteristics and how they relate to the subject is essential to understanding the role camera filters can play.

Lighting Contrast. The overall contrast of a photograph is a measure of the amount of difference between the highlight and the shadow values. The size of the light source illuminating the subject is the primary determining factor influencing overall contrast in the photo.

A small light source (like a spotlight) or a large light source positioned far from the subject (like the sun) will create a scene with high contrast. A large light source, like the sky on a heavily overcast day, produces low scene contrast.

*Changing the light source
or modifying its intensity
impacts image contrast . . .*

Changing the light source or modifying its intensity impacts image contrast, but this isn't always possible (or even desirable). That's where filters come in. There are filters available to both increase and decrease the overall contrast of a scene. (For more on this, see the discussion in chapter 6.)

Besides overall image contrast, there's also local contrast, which is the contrast between different elements close to one other within the composition. It's possible to have low local contrast in a composition of high overall contrast. For example, a shaft of sunlight striking the ground deep in the forest provides high overall contrast, yet the ferns in the shadowed foreground covering the forest floor have low local contrast. Filters provide a way

of dealing with such situations, whether the final photos are in black & white (monochrome) or color.

Light Direction. The angle between the subject and the light source also influences contrast, particularly when small light sources are involved. When the angle is small, for instance when the light source is directly behind the photographer or when the subject is backlit, the local contrast is generally low. It's interesting to note that in the first case, the overall contrast is also usually low and the lighting is termed "flat." In the second case, that of backlighting, while the local contrast is low, the overall contrast can be quite high.

As the angle between the light source and the subject increases from 0 to 90 degrees, the local contrast increases. From 90 to 180 degrees it decreases again, as the light moves behind the subject. It is important to be aware of light direction and the effect it will have on the photo, both for technical and aesthetic reasons.

Photographers working outside of the studio have only marginal control over the direction of the light source. They can only wait for a particular time of day to shoot. Fashion and glamour photographers frequently wait for that "golden hour" just after sunset, when the angle of light is low on the horizon. Sometimes, photographers can wait for the lighting condition to change, such as waiting for cloud cover or partial sun. At other times, they can adjust the position of the subject to find the optimum light angle. And they can add fill light from various directions, either through reflectors or electronic light sources.

Light Temperature. When we see a photograph taken at sunset, we say it looks "warm," because the predominant colors of the sunlight at that time of day are red, orange, and yellow. Visible light, the light to which human eyes respond, is made up of these colors as well as green and blue.

In the 17th century, Sir Isaac Newton demonstrated that when daylight passes through a prism, it is broken up into a series of colors: red, orange, yellow, green, blue, and violet. These are known as the chromatic colors. Those colors that are not a component of daylight, such as tan or burgundy, are known as non-chromatic colors.

Visible light makes up a small portion of the electromagnetic spectrum, as illustrated in the figure below.

What we call "white light" is actually light that contains roughly equal amounts of each chromatic color. This is the "daylight" for which daylight-type color film is balanced. But, in reality, daylight isn't the same on all points of the globe. The color of daylight changes from point to point on the planet, from one time to another during the day, and even from season to season. Modern color films are balanced for the "daylight" that is approximately the color of sunlight found in the northern latitudes at noontime during the summer on a clear day.

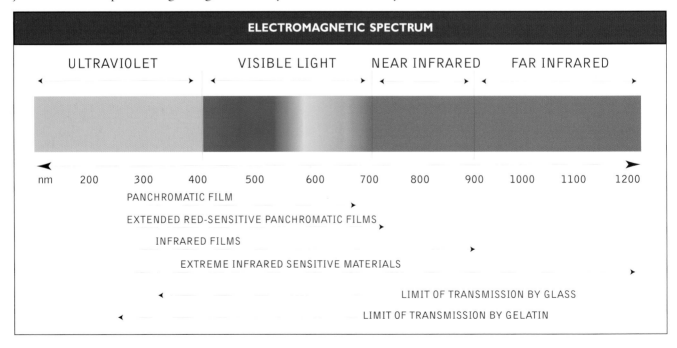

Color temperatures change throughout the day. At sunrise and sunset, the light has a golden color that reflects its lower color temperature.

Visible light that contains a greater proportion of the red end of the spectrum is considered "warm" light; conversely, light containing a greater portion of the blue end of the spectrum is considered "cool." These subjective impressions of color have been quantified for photography by means of the Kelvin temperature scale, a measure used by scientists to indicate the temperature to which a theoretical "black body" must be heated in order to radiate light of a specific hue (wavelength or combination of wavelengths). This scale allows the assignment of a color temperature, expressed in degrees Kelvin, to various sources of continuous light, including sunlight at different parts of the day. Color temperatures can be measured with a color temperature meter, which is an essential piece of equipment for any serious photographer interested in either maintaining a perfectly neutral color balance or shifting the color balance of a scene in a predictable way. The top professional digital cameras have an option to set the white balance of the sensor by directly entering the color temperature of the light in degrees Kelvin.

The table to the left gives the color temperature of various types of light sources. The "warmer" the light source, the lower its color temperature.

COLOR TEMPERATURES

SOURCE	COLOR TEMPERATURE (K)
Cloudless blue sky	12000 to 18000
Overcast sky	6000 to 8000
Average sunlight (two hours before and after noon)	5400
Photographic daylight	5500
Electronic flash (professional studio, bare tube)	5400 to 6400
Electronic flash (professional studio, in softbox)	4850 to 5950
Built-in or on-camera flash	5500 to 6500
HMI (halogen metal halide) bulb	5500 to 6000
500w Photoflood bulb	3400
Quartz-halogen bulbs	3200
200w household incandescent bulb	2980
100w household incandescent bulb	2900
75w household incandescent bulb	2820
40w household incandescent bulb	2650

PRIMARY COLORS

The eye does not act like a color temperature meter, which is sensitive to all wavelengths of the visible spectrum. To oversimplify somewhat, cone cells in the eye are sensitive only to red, green, and blue light. Thus,

ADDITIVE PRIMARY COLORS

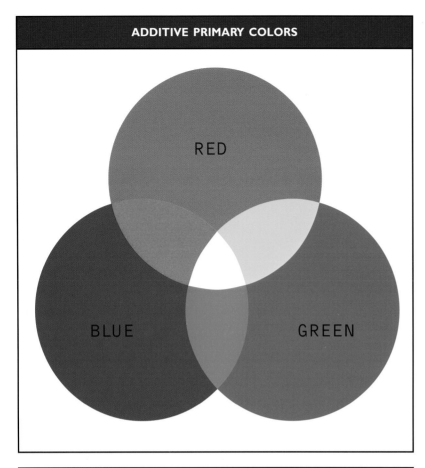

SUBTRACTIVE PRIMARY COLORS

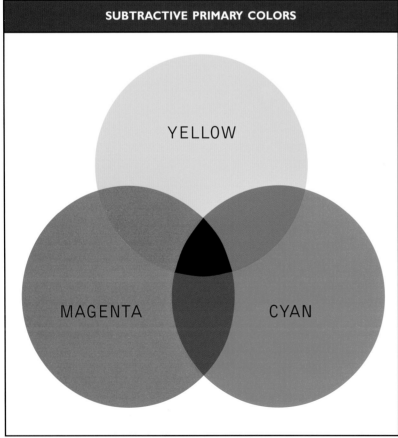

the eye can be "tricked" into giving the same response, in terms of color, to different stimuli. For example, the eye will perceive a light as being yellow if it in fact contains the wavelengths corresponding to yellow, or if the light is composed of red and green components (and no yellow component) of proper intensity!

The proper mixing of red, green, and blue light in the eye can duplicate any color sensation. If equal intensities of these colors are added together, the eye perceives the light as white light. For this reason, red, green, and blue (or RGB) are known as the additive primary colors.

This same sensation of white light can be achieved by mixing together light of two pure colors such as certain yellows and blues, reds, and blue-greens, or greens and magentas. These colors, which are opposite each other on the color wheel, are known as complementary colors. They play an important role in creating color contrast in photography.

There are also subtractive primary colors. These are colors that are created by combining equal amounts of the additive primary colors. These colors are magenta (red and blue combined), yellow (red and green combined), and cyan (blue and green combined). Along with black, the subtractive primaries are the colors of the inks used in the printing process to reproduce color photos in newspapers, magazines, and books.

An additive primary (for example, red) is complementary to its corresponding subtractive primary (cyan) as well as to the colors that make up the subtractive primary (blue and green). Along the same lines, subtractive primaries are complementary to their additive primaries and the colors that make them up. The color wheel on the next page graphically illustrates the relationship.

The relationship between the different types of colors may be a little difficult to follow, but understanding that relationship is essential to understanding how filters work, because color filters have their strongest effect on their complementary colors and the colors that make them up. This is true for both color and black & white photography.

ABSORPTION OF LIGHT

The colors we see are a result of the partial absorption of light by an object. When white light falls on an object, various pigments in the object absorb a portion of the spectrum. The wavelengths reflected back (or transmitted) produce the sensation of color to our eyes. For example, a green leaf contains pigments that absorb all colors of the visible spectrum except green, which is reflected back. Similarly, a sheet of red cellophane (or a red photographic filter) contains pigments that absorb all colors of the spectrum except red, which is transmitted. Understanding this relationship is also essential to understanding how filters work. Hardware filters do not add color to a scene; they can only absorb colors that are present.

UNDERSTANDING DIGITAL CAMERAS

In designing a digital SLR, manufacturers must make decisions that involve tradeoffs between a number of factors that affect image quality and shooting speed. It is important for digital camera shoppers to understand a little about these tradeoffs so they can choose the best camera for their needs.

Image Sensors. Digital cameras use light-sensitive, solid-state sensor arrays to capture an image of the scene. There are two broad-based types of sensors, CCD (charge-coupled device) and CMOS (complementary metal oxide semiconductor) sensors. Image sensors capture light with individual photo-

THE COLOR WHEEL

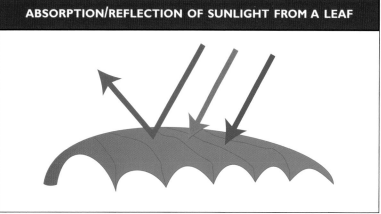

ABSORPTION/REFLECTION OF SUNLIGHT FROM A LEAF

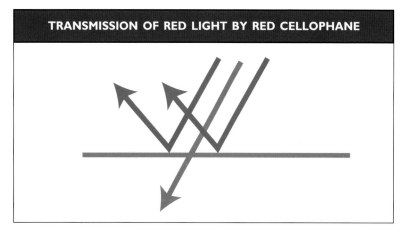

TRANSMISSION OF RED LIGHT BY RED CELLOPHANE

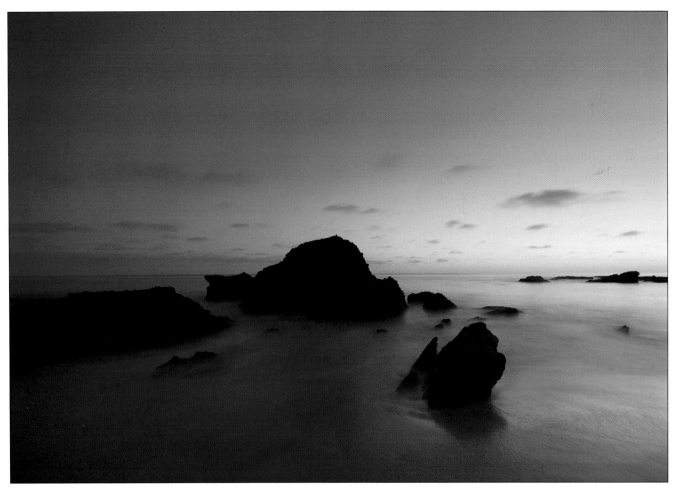

Compared to CMOS sensors, CCDs produce relatively little noise, which can be an asset in low-light situations.

diode detectors. The photons that strike the sensor are converted to a proportional number of electrons and stored at each individual sensor position. With a CCD, the number of electrons stored in each sensor is then read by control chips separate from the sensors themselves and sequentially stepped off of the charge transfer register. Once off of the CCD array, they are converted to their relative digital values.

CCDs were the first type of sensor used for digital capture devices and are still found in some digital SLRs. They provide excellent quality and relatively low noise, but they also require a set of dedicated chips to control and support them. Depending upon the camera design, sets of anywhere from three to eight additional chips are incorporated in the camera's image capture, conversion, and processing routine. The need for these additional chips, plus the fact that CCDs require a different manufacturing process than most computer chips, increases their cost over CMOS sensors.

There are specialized implementations of CCDs, such as for Fuji's S2 and S3 cameras or the Nikon D1x and the D2H and D2Hs, that provide higher resolutions and higher capture speed than conventional CCD implementations. CCDs are good at capturing images, but they have their limitations. As CCD resolutions climb, so does the cost of their production and the amount of support electronics that are required.

Two factors remain in the CCD's favor. One is their inherently lower noise. The other is that signals are processed off the sensor itself. This allows the individual pixels to take up more of the space in the array, rather than having to leave space for support electronics on the sensor array. And with the devices needed to amplify the signals on a separate chip rather than at each pixel, it is easier to match the output of one pixel to another with a CCD array than with a CMOS array. Where cost is less of an issue and quality is important, CCDs in medium format digital backs are still the best choice.

In digital SLRs, CMOS technology is taking over. Improvements in chip design and manufacturing as well as in signal processing and in noise reduction has put image quality from CMOS-based cameras on par with or, some people would argue, superior to CCD-based digital SLRs.

There are similarities between CCD and CMOS sensors. They have similar light sensitivity, which is primarily in the near- and far-IR spectrum. At the most basic level, both convert incident light into electronic charge by the same photo-conversion process.

While both CCD and CMOS chips are made of silicon, and both capture and convert light, they are different in design and operation. With CMOS, it's possible to produce entire digital cameras on a single chip—including the light sensor *and* support electronics. That significantly reduces production costs, space requirements, and power usage. Like CCDs, CMOS sensors also have individual sensor elements. Unlike CCDs, though, where the analog signals are stepped off of the chip registry before they are converted to digital, with CMOS sensors, the conversion of the electronic signal to a digital value is completed within the individual photo sensor.

That makes it possible to read-out the values of the individual sensors in a single step, rather than having to sequentially read the electronic signal off of the register, as is the case with CCDs. However, light sensitivity of a CMOS chip is lower than that of a CCD because space is needed on the chip for the transistors to process the signal. Many of the photons hitting the chip strike the transistors around the photodiode rather than the photodiode itself. As a result, the signal-to-noise ratio has always been lower in CMOS sensors than in CCDs. However, CMOS sensors don't suffer as greatly from the decrease in the signal-to-noise ratio as resolutions increase. That means higher-resolution digital cameras can be produced without having to significantly increase the supporting electronics.

Canon, in particular, has been aggressively implementing CMOS in its digital SLR design. All of their digital SLR cameras from the current top-of-the-line, full-frame EOS-1Ds Mark 2 on down are fashioned around CMOS sensors. Nikon continues to offer a choice. The D2X was their first CMOS-based camera, but it was followed by the CCD-based D200. Mixed in is the hybrid D2Hs. As with most things technological, it seems the implementation of the design is more important than the basis of it.

Creating Color. Both CCD and CMOS image sensors differentiate color through the use of mosaic filters. This is because the sensor elements themselves are only sensitive to the *amount* of light striking them (luminance), not the *color* of the light.

These filters, called Bayer filters after Dr. Bayer of Eastman Kodak who developed them, are bonded to the image sensors using a photolithography process that adds color dyes. Bayer filters use a checkerboard pattern with alternating rows of filters (see below). One row will alternate red and green filters while the row below will alternate blue and green.

BAYER FILTER ARRAY

Image sensors are only sensitive to the amount of light striking them, not the color of the light. Therefore, they differentiate color through the use of mosaic filters.

Some cameras, like the D2x, use a modified array. Nikon mixes in cyan (blue-green) filters in an effort to improve the sampling range, particularly for the colors to which our brains are most critical, green and blue.

Another problem is the need to interpolate the two (or more, in the case of the D2x) missing colors for the pixels. For each red pixel in a Bayer array, for example, the camera must come up with a value of green and blue for it. This is done by mathematically sampling the green and blue pixels surrounding the red pixel and coming up with a numerical value for the green and blue information. This interpolation can sometimes lead to color errors. The same must be done for the pixels that record blue and green information.

Micro Lenses. In some cameras, not only does each sensor element have a filter bonded to it, it may also have a micro-lens bonded to it. The micro-lens is needed to focus and concentrate the light, improving image quality and sensitivity. Many CMOS- and CCD-based sensors use these micro-lenses over the sensor elements. As pixel size decreases, the sensor arrays will need to increasingly rely on the consistent quality of these micro-lenses in order to maintain sensitivity and dynamic range.

Infrared Cutoff. Two additional filters are frequently used over the entire sensor array. One is an infrared cutoff filter. Since the photodiode image sensors are overly sensitive to infrared radiation, an infrared (IR) filter, which gives the sensor a cyan color when you see it in the camera, is mounted over the sensor. Chapter 10

In a complete Bayer array, there are as many green pixels as red and blue pixels combined. This is necessary because the eye is more sensitive to green light, so more green information is needed in order to create an image that the eye will perceive as accurate in color. Digital cameras use specialized de-mosaicing algorithms to convert the mosaic of separate colors into an image.

There are some problems inherent in this design, however. The filters can only be made to pass certain wavelengths of red, green, and blue light. As a result, only a partial range of hues of these colors is sampled.

covers removing this filter in order to create infrared photos.

Anti-Aliasing. The other filter is an anti-aliasing filter. When photodiodes sample information, they see a sharp distinction between dark and light and are unable to sample all of the high-frequency information. So when the color information is interpolated, extraneous data is created, resulting in moire patterns or randomly colored pixels in monochromatic areas and spectral highlights. To minimize these, an anti-aliasing filter is mounted over the sensor. Unfortunately, reducing this high-frequency information also means reducing sharpness.

Kodak digital SLRs, which are no longer available new, were unique in not incorporating an anti-aliasing filter over their sensor array. Kodak felt that the pixel size was small enough and resolution of the full-frame sensor was high enough that moire would not be an issue. Images from these cameras were noticeably sharper than those from others.

Resolution. Most photographers shopping for a digital SLR focus primarily on its resolution, the number of pixels the sensor has to capture the image. Resolution is determined by counting the number of pixels in a horizontal row and in a vertical column and multiplying these two numbers together. For example, a chip with 3000 pixels horizontally and 2000 pixels vertically has six million total pixels, so the camera in which it is mounted is called a 6-megapixel camera.

Purchasing a digital camera is a complicated decision. You need to be up to speed on the technology and aware of all the potential trade-offs to make an informed decision.

However, while this is the number that the camera manufacturer likes to quote, the resolution of the final image will not be exactly the same as the total number of individual pixels on a chip. Because of the way that sensors are designed into digital cameras, and the need to have a background electron flow standard to match against the captured signal (as a way to eliminate background noise), some of the pixels on the sensor are cut out of the image frame. This accounts for the difference between the total pixel number quoted in most camera

sales literature and the effective pixel number buried in the specifications. The important number is the number of effective pixels, because these are the ones that produce the image.

While there is no question that image quality improves with increased resolution, an 8-megapixel point-and-shoot camera is not going to produce a better image than a 5.3-megapixel (effective) Nikon D1x. The limiting factor is the area in which the sensor chip needs to fit.

In a digital SLR, this area is fixed. Packing more pixels into the same area means that the individual pixels must be made smaller. Smaller pixels are less sensitive to light and have less dynamic range, the range of brightness from highlight to deep shadow. While it is physically possible to shrink the pixels, it is more difficult to shrink the supporting electronics on a CMOS chip. Until the next advance in design and manufacturing, it would seem we have reached a point where increasing image resolution could well decrease image quality.

Currently, the resolution leader is the full-frame Canon EOS-1Ds with 16.7-megapixel (effective) resolution. There is no question that the image quality is excellent, but few photographers short of full-time professionals really need a 50MB file—and even *they* are trying to figure out how to store and access this amount of information conveniently.

As you can see, designing a digital camera involves making compromises. Do you use smaller pixels with micro-lenses that will render detail better and decrease the possibility of moire, or larger pixels without micro-lenses for better dynamic range? What type of filter array will deliver the most accurate color? Is a CCD or CMOS sensor the best choice for the intended applications of the camera?

Camera manufacturers have already made these decisions for each model they sell. As a digital photographer, you need to be aware of the tradeoffs in order to make an informed decision about which model fits your needs.

METERS

While many modern cameras have sophisticated built-in metering systems, handheld meters are helpful in many cases—and essential in some cases when using filters.

Light Meters. Because many filters work by absorbing some portion of the visible spectrum, less light is available to the film, so exposure must be increased. This exposure increase is called the "filter factor" and can range from $\frac{1}{3}$ stop to 3 stops or more for some filters. The table below gives the aperture adjustments for common filter factors.

F-STOP INCREASE REQUIRED FOR FILTER FACTORS

FILTER FACTOR	EXPOSURE INCREASE (STOPS)
1	0
1.2	$\frac{1}{3}$
1.4	$\frac{1}{2}$
1.5	$\frac{2}{3}$
2	1
2.5	$1\frac{1}{3}$
2.8	$1\frac{1}{2}$
3	$1\frac{2}{3}$
4	2
5	$2\frac{1}{3}$
6	$2\frac{2}{3}$
8	3
10	$3\frac{1}{3}$
12	$3\frac{1}{2}$
16	4
32	5
64	6

When filters are used in combination, there is an exponential increase in exposure time. The individual factors for the different filters are multiplied rather than added to obtain the final exposure correction. Therefore, two filters with filter factors of 4 require a 16x increase in exposure, not 8x. As exposure times increase, it's easy to see how a tripod becomes an essential piece of gear for the photographer using filters.

In some cases, the metering system built into the camera can accurately adjust for the filter factor. This is truer with lighter-colored filters in color photography than with the denser filters used in black & white. In-camera meters are least accurate when using the special-effects filters discussed in chapter 8 or when the scene contains a large proportion of the color that is being filtered out. For example, if a red filter is being used for a black & white photo at the beach where the scene is

made up of predominately blue water and blue sky, metering through the lens with the filter in place will likely produce massive underexposure since the filter is removing the blue components of the scene. In this and similar cases, it is best to meter without the filter, apply the filter factor, and manually set the adjusted exposure.

An incident light meter is useful in a large number of situations. It's particularly useful if you can attach an accessory reflected-light spot-metering attachment to it. Some meters have the spot-metering attachment built into the incident meter. Spot meters allow the measurement of small areas of the scene, which is useful when trying to determine, for instance, how much brighter the sunset sky is than the foreground subject. Many sophisticated meters also allow for the metering of electronic flash, which is useful in studio situations.

When using these meters, there are several ways to adjust for the light loss caused by the filter that will be used over the camera lens.

After taking an incident or reflected light reading, you can use the filter factor to calculate the amount the aperture must be opened up or the shutter speed increased, then set the camera manually.

A simpler way is to adjust the ISO setting of the meter before making the reading. Simply divide the ISO speed at which the digital camera is set by the filter factor. For example, if the filter factor is 2, set the ISO on the meter to 100 divided by 2, or 50. Then, the shutter speed and aperture reading can be read directly from the meter and transferred to the camera with no further adjustment. Just remember to adjust the ISO setting on the meter for each different filter—and to adjust it back again when no filter is being used.

Color-Temperature Meters. As mentioned earlier, when it is necessary to shift the color balance of a scene in a predictable way, a color-temperature meter is essential. Although expensive, this type of meter gives the photographer greater control over color balance.

A color temperature meter can be used to produced balanced color (left) of to shift the color in predictable ways (right).

There are two types of color-temperature meters: two-color and three-color meters. Two-color meters work only with light sources that emit a continuous spectrum of light, such as the sun or an incandescent bulb. Three-color meters work with continuous spectrum sources as well as with some discontinuous sources, such as fluorescent lights.

Color temperature meters
make it possible to
predictably control the use of color.

Architectural interior photographers rely heavily on three-color meters for their work. Often each light source in an interior shot must be exposed separately, with the proper correction filter determined by use of the color temperature meter, in order to render the scene as the eye sees it. Studio photographers also rely on color temperature meters to measure the color temperature of electronic flash heads. They can then add filtration to each head or softbox diffuser so that the light emitted by each will be of the same color temperature. Then, if necessary, filters are added to the camera lens to balance the lights, yielding a neutral rendition on film.

There are times when, for aesthetic reasons, you may want to render the scene warmer or cooler than neutral. In these cases, the color temperature meter is used to determine a filter to render the scene neutral and then a filter pack (a specific combination of filters) is calculated to provide a predictable amount of color shift.

While color temperature meters take some time to calibrate and some experience to use successfully, they make it possible to predictably control the use of color in a variety of situations and shooting conditions.

In-Camera Controls. Digital SLRs are increasingly offering color temperature controls as a menu option. The Nikon D2x, for example, lets you choose a color temperature from 2,500 Kelvin to 10,000 Kelvin, selecting from over thirty preset values. Canon models offer similar settings.

I have found that these settings don't exactly correspond to the measurements from a color-temperature meter, but they are close in all cases other than fluorescent or flash. So if you have a color-temperature meter, you can use it in combination with these settings. And, of course, if you are capturing images in the RAW file format, you can always readjust them with the color-temperature controls that the manufacturer's RAW conversion software makes available to you.

As sophisticated as the metering systems are in the current crop of digital SLR cameras, I always carry a handheld meter with me.

RESOURCES

adobe.com—Adobe Photoshop and Adobe Photoshop Elements image-editing software.

autofx.com—Auto FX Mystical Tint, Tone, and Color Effects; Mystical Lighting Effects software for Mac and Windows.

chromasoftware.com—Chroma Software Photographic Filters and IR Film software for Windows only.

cokin.com—Cokin hardware filters.

corel.com—Corel Draw and Corel Paint Shop Pro.

digitalfilmtools.com—Digital Film Tools 55mm software for Mac and Windows.

epson.com—Epson printers.

inkjetmall.com—B/W Piezography inks.

leefilterusa.com—Lee hardware filters.

lensbabies.com—Lensbaby and Lensbaby 2.0 lenses for digital SLR cameras.

nikmultimedia.com—Nik Color Efex Pro software for Mac and Windows.

optikvervelabs.com—Virtual Photographer, for Windows only.

pixelgenius.com—PhotoKit and PhotoKit Color for Mac and Windows (Photoshop 7, CS, and CS2 only.) PhotoKit-EL for Photoshop Elements 2.0 and PhotoKitEL-3 for Photoshop Elements 3.0.

powerretouche.com—PowerRetouche software for Mac and Windows.

schneideroptics.com/filters/filters_for_still_photography/—B+W hardware filters.

theimagingfactory.com—Adobe-compatible plug-ins for Mac and Windows.

tiffen.com—Tiffen hardware filters.

ulead.com—Ulead PhotoImpact image-editing software.

INDEX

MACRO & CLOSE-UP PHOTOGRAPHY HANDBOOK

Stan Sholik and Ron Eggers

Learn to get close and capture breathtaking images of small subjects—flowers, stamps, jewelry, insects, etc. Designed with the 35mm shooter in mind, this is a comprehensive manual full of step-by-step techniques. $29.95 list, 8½x11, 120p, 80 b&w and color photos, order no. 1686.

PORTRAIT PHOTOGRAPHER'S HANDBOOK, 2nd Ed.

Bill Hurter

Bill Hurter has compiled a step-by-step guide to portraiture that easily leads the reader through all phases of portrait photography. This book will be an asset to experienced photographers and beginners alike. $29.95 list, 8½x11, 128p, 175 color photos, order no. 1708.

THE MASTER GUIDE TO DIGITAL SLR CAMERAS

Stan Sholik and Ron Eggers

What makes a digital SLR the right one for you? What features are available? What should you look out for? These questions and more are answered in this helpful guide. $29.95 list, 8½x11, 128p, 180 color photos, index, order no. 1791.

PROFESSIONAL DIGITAL PHOTOGRAPHY

Dave Montizambert

From monitor calibration, to color balancing, to creating advanced artistic effects, this book provides those skilled in basic digital imaging with the techniques they need to take their photography to the next level. $29.95 list, 8½x11, 128p, 120 color photos, order no. 1739.

OUTDOOR AND LOCATION PORTRAIT PHOTOGRAPHY, 2nd Ed.

Jeff Smith

Learn to work with natural light, select locations, and make clients look their best. Packed with step-by-step discussions and illustrations to help you shoot like a pro! $29.95 list, 8½x11, 128p, 80 color photos, index, order no. 1632.

THE BEST OF NATURE PHOTOGRAPHY

Jenni Bidner and Meleda Wegner

Ever wondered how legendary nature photographers like Jim Zuckerman and John Sexton create their images? Follow in their footsteps as top photographers capture the beauty and drama of nature on film. $29.95 list, 8½x11, 128p, 150 color photos, order no. 1744.

CREATIVE LIGHTING TECHNIQUES FOR STUDIO PHOTOGRAPHERS, 2nd Ed.

Dave Montizambert

Whether you are shooting portraits, cars, tabletop, or any other subject, Dave Montizambert teaches you the skills you need to take complete control of your lighting. $29.95 list, 8½x11, 120p, 80 color photos, order no. 1666.

THE ART OF BLACK & WHITE PORTRAIT PHOTOGRAPHY

Oscar Lozoya

Learn how master photographer Oscar Lozoya uses unique sets and engaging poses to create black & white portraits that are infused with drama. Includes lighting strategies, special shooting techniques, and more. $29.95 list, 8½x11, 128p, 100 duotone photos, order no. 1746.

CORRECTIVE LIGHTING, POSING & RETOUCHING FOR DIGITAL PORTRAIT PHOTOGRAPHERS, 2nd Ed.

Jeff Smith

Learn to make every client look his or her best by using lighting and posing to conceal real or imagined flaws—from baldness, to acne, to figure flaws. $34.95 list, 8½x11, 120p, 150 color photos, order no. 1711.

THE BEST OF WEDDING PHOTOGRAPHY, 2nd Ed.

Bill Hurter

Learn how the top wedding photographers in the industry transform special moments into lasting romantic treasures with the posing, lighting, album design, and customer service pointers found in this book. $34.95 list, 8½x11, 128p, 150 color photos, order no. 1747.

SUCCESS IN PORTRAIT PHOTOGRAPHY

Jeff Smith

Many photographers realize too late that camera skills alone do not ensure success. This book will teach photographers how to run savvy marketing campaigns, attract clients, and provide top-notch customer service. $29.95 list, 8½x11, 128p, 100 color photos, order no. 1748.

PROFESSIONAL TECHNIQUES FOR
PET AND ANIMAL PHOTOGRAPHY

Debrah H. Muska

Adapt your portrait skills to meet the challenges of pet photography, creating images for both owners and breeders. $29.95 list, 8½x11, 128p, 110 color photos, index, order no. 1759.

THE PORTRAIT BOOK

A GUIDE FOR PHOTOGRAPHERS

Steven H. Begleiter

A comprehensive textbook for those getting started in professional portrait photography. Covers every aspect from designing an image to executing the shoot. $29.95 list, 8½x11, 128p, 130 color images, index, order no. 1767.

THE MASTER GUIDE FOR WILDLIFE PHOTOGRAPHERS

Bill Silliker, Jr.

Discover how photographers can employ the techniques used by hunters to call, track, and approach animal subjects. Includes safety tips for wildlife photo shoots. $29.95 list, 8½x11, 128p, 100 color photos, index, order no. 1768.

HEAVENLY BODIES

THE PHOTOGRAPHER'S GUIDE TO ASTROPHOTOGRAPHY

Bert P. Krages, Esq.

Learn to capture the beauty of the night sky with a 35mm camera. Tracking and telescope techniques are also covered. $29.95 list, 8½x11, 128p, 100 color photos, index, order no. 1769.

PLUG-INS FOR ADOBE® PHOTOSHOP®

A GUIDE FOR PHOTOGRAPHERS

Jack and Sue Drafahl

Supercharge your creativity and mastery over your photography with Photoshop and the tools outlined in this book. $29.95 list, 8½x11, 128p, 175 color photos, index, order no. 1781.

POWER MARKETING FOR WEDDING AND PORTRAIT PHOTOGRAPHERS

Mitche Graf

Set your business apart and create clients for life with this comprehensive guide to achieving your professional goals. $29.95 list, 8½x11, 128p, 100 color images, index, order no. 1788.

THE DIGITAL DARKROOM GUIDE WITH ADOBE® PHOTOSHOP®

Maurice Hamilton

Bring the skills and control of the photographic darkroom to your desktop with this complete manual. $29.95 list, 8½x11, 128p, 140 color images, index, order no. 1775.

BEGINNER'S GUIDE TO ADOBE® PHOTOSHOP® ELEMENTS®

Michelle Perkins

Packed with easy lessons for improving virtually every aspect of your images—from color balance, to creative effects, and more. $29.95 list, 8½x11, 128p, 300 color images, index, order no. 1790.

BEGINNER'S GUIDE TO PHOTOGRAPHIC LIGHTING

Don Marr

Create high-impact photographs of any subject with Marr's simple techniques. From edgy and dynamic to subdued and natural, this book will show you how to get the myriad effects you're after. $29.95 list, 8½x11, 128p, 150 color photos, index, order no. 1785.

THE PORTRAIT PHOTOGRAPHER'S
GUIDE TO POSING

Bill Hurter

Posing can make or break an image. Now you can get the posing tips and techniques that have propelled the finest portrait photographers in the industry to the top. $29.95 list, 8½x11, 128p, 200 color photos, index, order no. 1779.

MASTER LIGHTING GUIDE

FOR PORTRAIT PHOTOGRAPHERS

Christopher Grey

Efficiently light executive and model portraits, high and low key images, and more. Master traditional lighting styles and use creative modifications that will maximize your results. $29.95 list, 8½x11, 128p, 300 color photos, index, order no. 1778.

PROFESSIONAL DIGITAL
IMAGING FOR WEDDING AND
PORTRAIT PHOTOGRAPHERS
Patrick Rice

Build your business and enhance your creativity with practical strategies for making digital work for you. $29.95 list, 8½x11, 128p, 200 color photos, index, order no. 1780.

DIGITAL INFRARED
PHOTOGRAPHY
Patrick Rice

The dramatic look of infrared photography has long made it popular—but with digital it's actually *easy* too! Add digital IR to your repertoire with this comprehensive book. $29.95 list, 8½x11, 128p, 100 b&w and color photos, index, order no. 1792.

THE PRACTICAL GUIDE
TO DIGITAL IMAGING
Michelle Perkins

This book takes the mystery (and intimidation!) out of digital imaging. Short, simple lessons make it easy to master all the terms and techniques. $29.95 list, 8½x11, 128p, 150 color images, index, order no. 1799.

DIGITAL LANDSCAPE
PHOTOGRAPHY STEP BY STEP
Michelle Perkins

Using a digital camera makes it fun to learn landscape photography. Short, easy lessons ensure rapid learning and success! $17.95 list, 9x9, 112p, 120 color images, index, order no. 1800.

BEGINNER'S GUIDE TO
ADOBE® PHOTOSHOP®, 3rd Ed.
Michelle Perkins

Enhance your photos, create original artwork, or add unique effects to any image. Topics are presented in short, easy-to-digest sections that will boost confidence and ensure outstanding images. $34.95 list, 8½x11, 128p, 80 color images, 120 screen shots, order no. 1823.

THE BEST OF PROFESSIONAL
DIGITAL PHOTOGRAPHY
Bill Hurter

Digital imaging has a stronghold on the photographic industry. This book spotlights the methods that world-renowned photographers use to create their standout images. $34.95 list, 8½x11, 128p, 180 color photos, 20 screen shots, index, order no. 1824.

PROFESSIONAL
PORTRAIT LIGHTING
TECHNIQUES AND IMAGES FROM
MASTER PHOTOGRAPHERS
Michelle Perkins

Get a behind-the-scenes look at the lighting techniques employed by the world's top portrait photographers. $34.95 list, 8½x11, 128p, 200 color photos, index, order no. 2000.

HOW TO CREATE A HIGH PROFIT
PHOTOGRAPHY BUSINESS
IN ANY MARKET
James Williams

Whether your studio is located in a rural or urban area, you'll learn to identify your ideal client type, create the images they want, and watch your financial and artistic dreams spring to life! $34.95 list, 8½x11, 128p, 200 color photos, index, order no. 1819.